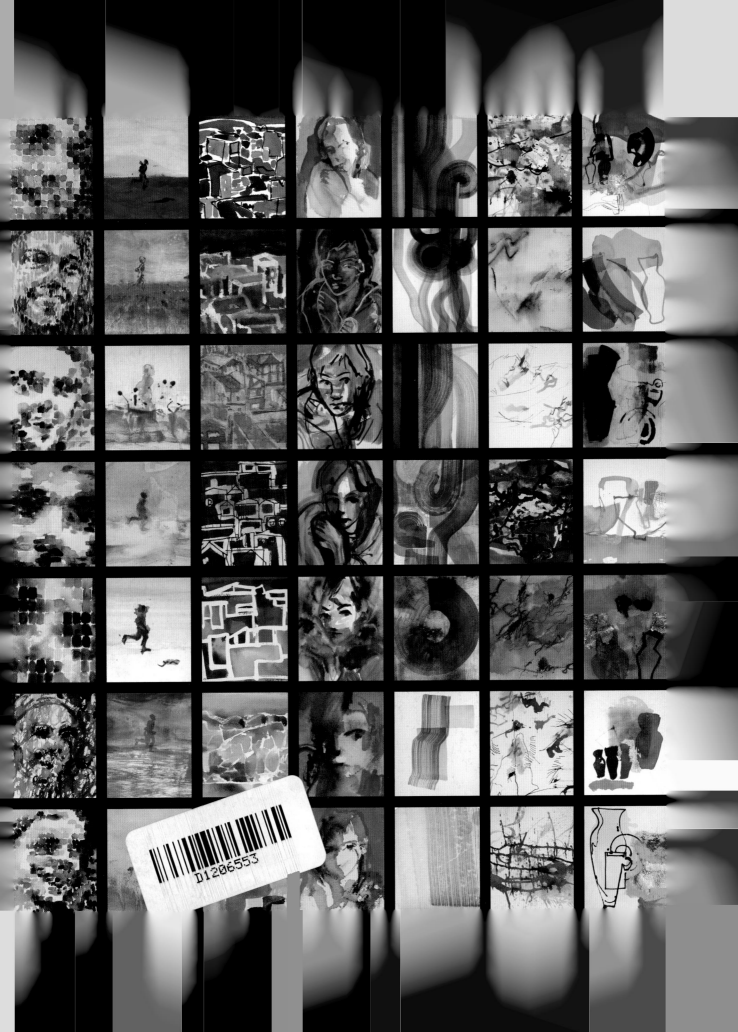

Creative Watercolor

Creative Watercolor

Project and Production by Parramon Publishing, Inc.

Editorial Director: Maria Fernanda Canal
Editorial and Image Archive Assistant:
Maria Carmen Ramos
Text: Josep Asuncion and Gemma Guasch
Implementation of Exercises: Josep Asuncion and Gemma
Guasch
Editing and final Drafting: Maria Fernanda Canal,
Roser Perez
Collection Design: Toni Ingles
Photography: Estudi Nos & Soto, Creart

Layout: Estudi Toni Ingles
Production Director: Rafael Marfil
Production: Manel Sanchez

Translated from Spanish by Eric A. Bye, M.A., C.T.

First edition for the United States, Canada, and its territories
and possessions published by Barron's Educational Series,
Inc.

English language translation © Copyright 2010 by Barron's
Educational Series, Inc.

Original title of the book in Spanish: *Acuarela Creativa*
© Copyright 2008 PARRAMON EDICIONES, S.A.,—World Rights
Published by Parramón Ediciones, S.A., Barcelona, Spain

All inquiries should be addressed to:
Barron's Educational Series, Inc.
250 Wireless Boulevard
Hauppauge, New York 11788
www.barronseduc.com

ISBN-13: 978-0-7641-6296-1
ISBN-10: 0-7641-6296-9

Library of Congress Catalog Card No. 2009936585

Printed in China
9 8 7 6 5 4 3 2 1

CREATIVE TECHNIQUES

Creative Watercolor

BARRON'S

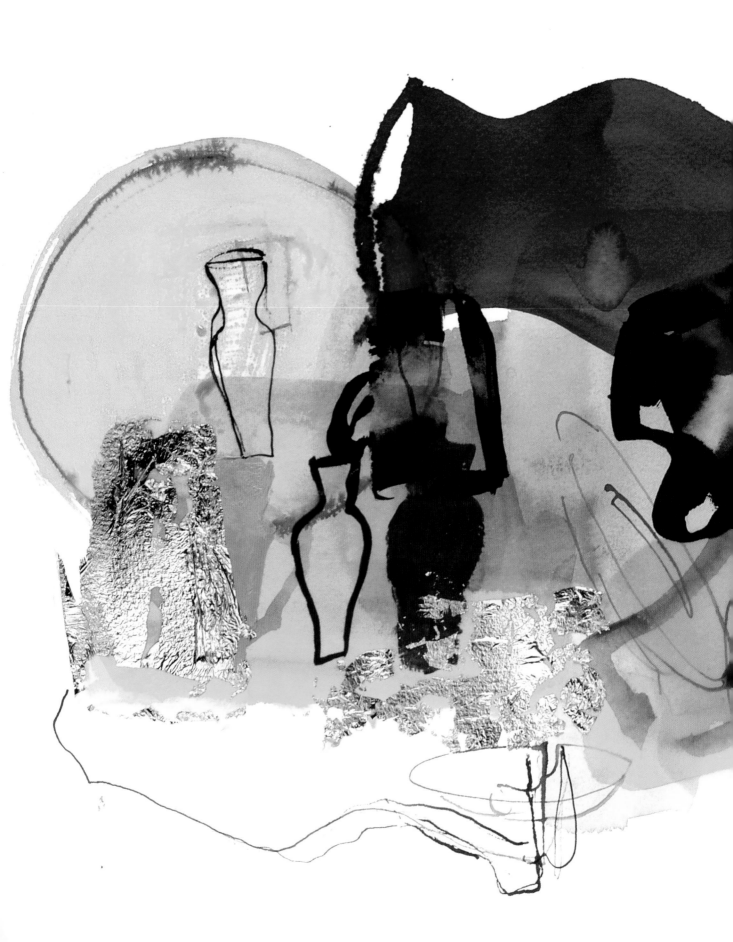

Contents

Introduction	**7**
Materials and Techniques	**8**
Paints	8
Supports and Substances	10
Applicators	12
Basic Techniques	14
Creative Projects	**22**
Creative Project 01: Transparencies *Creating Impressions of Color Through Transparencies*	24
Creative Project 02: Hatching *Painting Landscapes with Hatching and Linear Strokes*	32
Creative Project 03: Outline and Shape *Defining the Figure by Integrating Line and Shape*	40
Creative Project 04: Lyricism *Communicating Lyricism and Poetry in an Austere Still Life*	48
Creative Project 05: Atmospheres *Producing Atmosphere in a Landscape by Means of Glazes and Fades*	56
Creative Project 06: Imaginary Spaces *Uniting the Languages of Drawing and Painting to Create Fantastic Landscapes*	64
Creative Project 07: Wet on Wet *Experimenting with the Deliquescence of Color and its Expressiveness*	72
Creative Project 08: Optical Mixing *Painting a Portrait Through the Fragmented Decomposition of the Image*	80
Creative Project 09: Textures *Mixing Substances with Watercolor to Create Textured Effects*	88
Creative Project 10: Cloisonné *Constructing a Landscape in Divided Planes and Color Reserves*	96
Creative Project 11: Expressionism *Self-Expression Through Direct Brushstrokes of Color that Value a Certain Disdain*	104
Creative Project 12: Fields of Color *Composing Geometrical Abstractions with Flat Patches of Color*	112
Creative Project 13: Gestural Abstraction *Exploring the Expressive Possibilities of Gesture in Abstraction*	120
Creative Project 14: Combined Mediums *Combining Watercolor with Other Mediums to Gain Expressive Richness*	128
Glossary of Elements in Visual Language	**136**
Form	136
Color	138
Space	140
Stroke	142

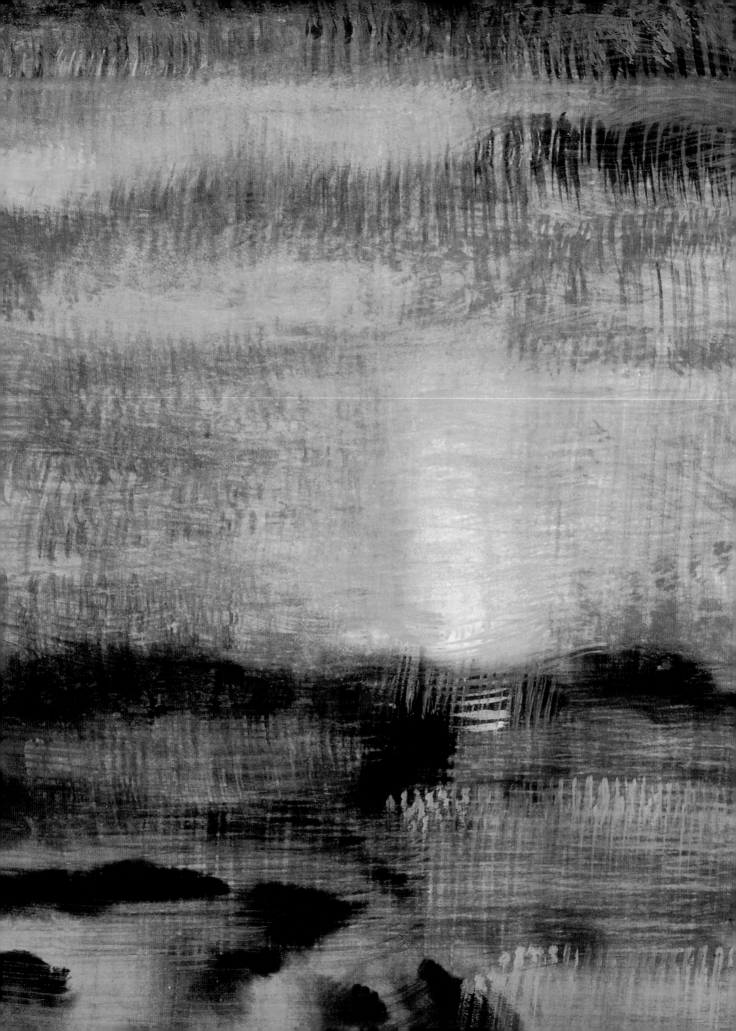

Both are artists and professors of painting in the School of Arts and Trades of the Council of Barcelona. As creative artists, they work in contemporary painting as well as in new artistic idioms: action art, video art, and photography. They have exhibited their work in various cities in Spain and Europe. Their long experience in instruction, as well as their work in research and artistic creation, is the source for the content of this book. Gemma Guasch and Josep Asunción are also the authors of the books *Form, Color, Space,* and *Line* in the "Creative Painting" collection published by Parramon Publishing, a book that has been warmly received by a reading public that is increasingly interested in painting as a means of developing creativity.

Introduction

The first European school for watercolors was founded in 1534, and was sponsored by Albrecht Dürer (1471–1528); however, the history of watercolor is much more ancient, and is connected to paper, its principal support. In fact, the Egyptians were familiar with and used gouache, and the Chinese have left us exquisite watercolors from the eighth century, done on silk and paper. It was in the course of the eighteenth and nineteenth centuries that watercolor took on an identity of its own. Van Dyck (1599–1641), Thomas Gainsborough (1727–1788), and John Constable (1776–1837) used watercolor to sketch out subsequent works in oil, and to color drawings and notes; on the other hand, Paul Sandby (1725–1809) and William Turner (1775–1850) furthered major advances, considering it a medium unto itself, autonomous and as capable of awakening expressive emotions as other mediums.

What characterizes a watercolor is its very vehicle: water. The main attraction of this technique comes from the deliquescence of the color in water. It is the protagonist, the color is manifested in it, forming attractive textural effects and transparencies that emphasize its purity. This deliquescence leads to the creation of gradations, precipitations, or dispersions of the pigment, spontaneous forms created in the stagnant color, luminous transparencies, and atmospheric glazes. This entire rich register of sensations is the seductive part of a watercolor; it really gives rise to an appreciation of what is known as "autonomy of the paint," since the medium collaborates with the artist and surprises with unexpected results.

Another basic trait of watercolor is its direct, essential character. A good watercolor is fresh, and shows no retouching; even though its appearance may be fragile and delicate, each patch is in its place and is accepted the way it turned out, which makes it radical and expressive. On the part of the painter, this requires control over the number of interventions: on the one hand, to avoid smothering the light of the work, which depends on the breathing of the paper, and on the other, to avoid killing the spontaneity of the medium.

Time control is also important. It is important to know when to act, for by observing at what point in the drying the interventions are done we can work at will on dry, moist, or wet surfaces. Stopping to observe as we paint allows us to gain distance, recognize the effects we are creating, and integrate them into the work.

The hackneyed idea that accuses watercolor of boldness because it does not allow corrections is false. Of course, the greater the penetration of the color into the fiber, the more difficult it is to make changes, but this depends on the sizing in the paper and the time that passes after every intervention. Nowadays, the sizings are very well balanced, and there are substances that slow down that penetration. The real risk involved with watercolor is that it is a "naked" medium that leaves evidence of the artists' skill and expressiveness, but also their doubts and clumsiness, and that makes them vulnerable. The more they try to disguise or hide what they were not expecting, the lower their work sinks. The solution is to allow whatever appears, whether it is intense or feeble, clumsy or skillful, lively or subdued. That way, they always win.

Paints

PRESENTATIONS

There are many companies in the marketplace that manufacture very high-quality watercolors. They are available in tubes or cakes. Watercolor in tubes is creamier. Tubes come in various sizes, individually or in boxes. Paint from cakes or pans is easily dissolved by rubbing it with a wet brush. Both come in compact boxes whose covers are used as a palette for mixing. Currently several brands market individual pans of larger size that make it possible to take up the color with large pencil brushes or paintbrushes.

The quality of watercolor in tubes is identical to that of the cakes; the artist chooses based on practical preferences. Tubes allow working with a greater quantity of paint; with the cakes you use just the right amount. Small cakes do not allow working with large brushes; on the other hand, tubes or large pans offer the possibility of working with large pencil brushes, paintbrushes, or sash brushes. On the other hand, the cakes in boxes are easier and more convenient to carry around.

A BASIC PALETTE

A basic watercolor palette should combine transparent and luminous colors with solid ones that cover well. The color white exists, but it is used on rare occasions, since the white of the paper is used through transparency. Black is also not very common, although it is available. The following may be a good color range:

Two excellent yellows: lemon yellow—very luminous and transparent—and cadmium yellow—dark, solid, opaque, and slightly earthy.

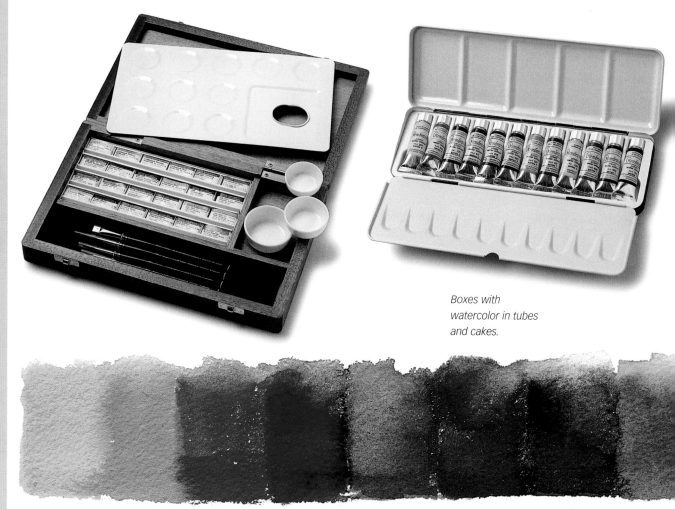

Boxes with watercolor in tubes and cakes.

W atercolor paints are characterized by their transparency and color purity. They are composed of finely ground pigments and a water-soluble binder. The most common binder is gum arabic, although tragacanth is also used; both are produced from the secretion of certain plants. These paints include honey and glycerin in their mix. The honey increases the plasticity, and the glycerin facilitates mixing the paint with water.

OTHER WATERCOLOR MEDIUMS

Two reds that are essential for their chromatic force: vermilion and quinacridone red, which is more luminous and changes less than cadmium red when it dries.
Three blues: cerulean—luminous and transparent; ultramarine—deep and slightly purplish; and Prussian blue—dark and nearly black.

The spectrum of greens is very broad: two basic ones are phthalocyanine green—yellowish, with a vibrant, clean, and luminous tonality—and the traditional Hooker green—deep and slightly dark. Finally, the palette should never lack an earth color, such as natural umber—with a greenish tonality—or burnt umber—more reddish and opaque.

There are very special and attractive colors such as Payne gray, indigo blue, quinacridone pink, emerald green, and natural sienna; incorporated into a basic palette, they enrich it considerably. In general, each painter gets used to an individualized palette made of the colors that are most closely connected with the person's work and make up a unique, personal chromatic spectrum.

Basic range of watercolors.

Watercolor Crayons and Pastels
Watercolor crayons and pastels are made with glycol, a water-soluble binder. They are available in sticks, and they form washes when they are moistened with water. The results differ a little from watercolor because they don't contain as much pigment, but they are more solid and stronger than those achieved with watercolor pencils. They can be used over washes, but they always show the strokes. Dry, on top of watercolor, their colors are opaque and brilliant and give the work expressiveness and strength.

Liquid Watercolors
Also referred to as artist's inks, their composition is similar to that of India ink, but dyes rather than pigments are used in them. The colors are transparent and not very permanent; they fade with time and the effects of sunlight. They are easy to use and can be lightened with bleach to create beautiful effects. The color ranges are very extensive and varied, and depending on the brands they turn out more or less brilliant.

Watercolor Markers
These are water-based markers. Since it takes time for them to dry, water can be used over them, which produces effects of wet on wet: diffusing and loss of outline, just as with watercolor. Depending on their opacity, they can be superimposed over one another to create a third color. A load of pigment is added to some markers to make the color opaque, similar to gouache.

Watercolor Pencils
These are colored pencils with a hard lead of high quality that can be diluted with water. The lines they make are light and transparent, but that is offset by the fact that they can be used to create washes. The results cannot be compared with those of watercolors, since they scarcely contain any pigment, but they are remarkable for their refinement and elegance.

Watercolor graphite pencils, like normal pencils, contain crystallized carbon, but in addition they have a soluble binder. They are offered in the form of a pencil or a round or hexagonal stick. They can be applied by either first moistening the stick or else using a moistened brush over the line to form suggestive washes.

1. Watercolor pastels
2. Liquid watercolor
3. Watercolor marker
4. Watercolor pencils
5. Watercolor graphite pencils

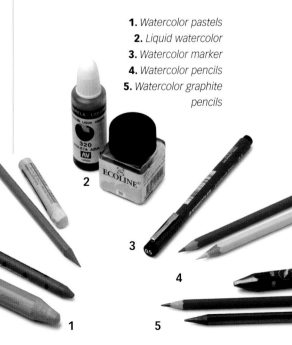

Supports and Substances

PAPERS

Paper is made up of cellulose fibers of plant origin that are extracted from wood (eucalyptus, pine), or from plants (cotton, linen, hemp, etc.). Glue is added to these fibers to make them waterproof and keep them from coming apart when they get wet. There is a great selection of industrial and craft papers on the market that are ideal for painting with watercolor.

Satin paper

Fine-grained paper

Medium-grained paper

Coarse-grained paper

Fiber

Papers for watercolor are made from cotton, although the manufacturers mix this fiber with others for reasons of economy. Normally there is a relationship between the quality of the fiber and the price of the paper, so inexpensive papers commonly contain low-quality fibers. Rag paper is of higher quality; it is produced by recycling cotton and linen clothing, and it is very durable.

Surface

In wet techniques, it is common to use smooth or rough finishes of fine, medium, or coarse grain, depending on the desired effect. In satin or fine-grained finishes, the color has more sheen and spreads easily over the surface. On the other hand, with medium- or fine-grained papers, the watercolor is absorbed quickly and is more difficult to spread, and the roughness is visible in the stroke.

Paper for watercolor is sold in blocks or individual sheets of different weights, textures, and sizes.

Weight

The weight of the paper is determined by its thickness. It indicates how many pounds a ream, or how many grams per one square meter, the paper weighs. Papers for watercolor need to have a heavy weight, at least 140 pounds per ream / 300 gsm. A heavyweight paper can take lots of water without buckling, and it can be painted on persistently without problems.

Sizing

In contrast to other papers, watercolor paper is sized "in the pulp" while the pulp is being refined, and "on the surface" once the sheet is formed and dry. The first sizing affects how the color spreads on the fiber, and the second, how it is retained on the surface before being absorbed.

Watercolor papers customarily have a balanced sizing for this technique. To test it, you merely need to moisten a sheet with a little water and watch how long it takes to absorb it.

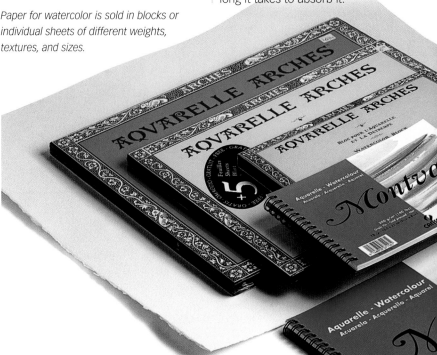

aper and watercolor are closely connected. The former is the support *par excellence*, and its quality is one basic aspect of painting. The fiber, the texture, the weight, and the sizing determine the results. The mediums are substances that modify the performance of the watercolor, such as gum arabic and ox gall. There are also new mediums on the market that create novel effects when combined with water. It is also feasible to work with more peculiar substances, such as salt, bleach, or oily substances to create textural effects.

SUBSTANCES

Gum Arabic

This retards the drying of the paint and gives the watercolors greater transparency and shine. With gum arabic, the color has more luminosity and depth.

Ox Gall

This is the moisturizing agent that improves the fluidity of the brushstroke. It is not applied directly onto the paper; a few drops are added to a bottle with water and this is used to dilute the watercolor. A preliminary coat of thinned bile on hard or heavily sized papers makes possible fluid progress of the work.

Alcohol

Traditionally this has been diluted with water and then added to the paint in order to speed up drying. If it is applied over watercolor that is still wet on the paper, it opens up clear areas with rings and gradations.

Frisket or Masking Film

This is used to set aside areas on the paper by making them impermeable to the watercolor. They must be allowed to dry before painting over them. Once they are dry, the color cannot penetrate. When the work is finished and fully dry, the mask is removed with tweezers, a rag, or simply with the fingers. The film is available in various densities and colors, and it is often difficult to clean the brush used to apply it.

Prepared Mediums for Watercolors

The composition of the mediums may include oils, varnishes, solvents, fixatives, or fillers, probably mixed with one another, depending on the purpose. The "medium for watercolor" traditionally sold combines the properties of gum arabic and ox gall; in addition, it increases the moistness of the paper, which improves the fluidity of the color. It is used thinned with water, diluted with the color, or directly by adding it to the water in the pot. It should not be used straight from the bottle. There are other mediums that help with the work and encourage creative experimentation: granulation medium, which changes the smooth appearance of the watercolor into a granulated or mottled texture; blending medium, which is used to delay the drying time; lifting medium, a new substance that is applied to the paper hours before using it, and which makes it possible to open up clear spots and make corrections with great ease; texture medium, which contains tiny texture particles that add expressiveness to the patches; iridescent medium, which gives the color a pearly sheen; and finally, aquapasto, a transparent gel that gives the watercolor body.

Fixative

This comes in aerosol form. It fixes the watercolor to the paper in such a way that work can continue without the risk of removing the fixed layers.

1. *Salt*
2. *Alcohol*
3. *Gum arabic*
4. *Ox gall*
5. *Aerosol fixative*
6. *Watercolor medium*
7. *Masking*
8. *Lifting medium*
9. *Iridescent medium*
10. *Aquapasto*

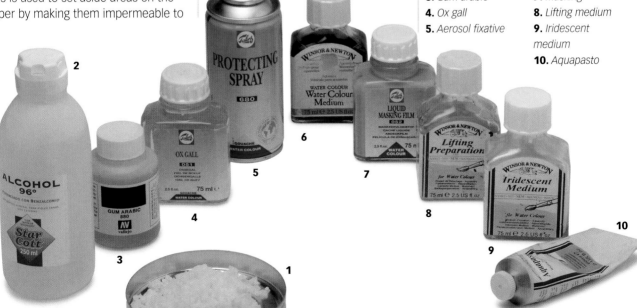

Applicators

ARTIST'S BRUSHES

The quality of a good artist's brush is determined by its ability to hold dissolved paint and to bend without effort, quickly recovering its shape and its point; it is thus appropriate to use brushes that are smooth but not too soft.

Component Parts
Every brush consists of three parts: handle, ferrule, and brush head.

Handle
The quality is determined by the type of wood and the lacquer or varnish used. Currently handles are also made from methacrylate and plastic. The latter make it possible to fill the inside with water, and they are ideal for working *en plein air*. Watercolor brushes tend to have a shorter handle than brushes for oils.

Ferrule
This is the part of the brush that holds the brush head to the handle, and it needs to fit tightly. Ferrules are made from aluminum and copper. The best quality ferrules are chrome plated, for they do not oxidize and they have clearly defined rings to hold the brush head. Their shape determines the shape of the brush head. Asian artist's brushes do not have ferrules; the hairs are glued or tied right to the handle, which makes them more delicate and fragile.

Hair or Brush Head
The most common kinds are of animal origin. The most highly esteemed hairs come from the Kolinsky marten, because of their ability to hold paint and their extreme smoothness, flexibility, and spring, which allows them to recover their shape quickly after every brushstroke. Other hairs commonly used in watercolor are those of the mongoose, squirrel (*petit gris*), and ox ear. Currently synthetic hairs have become well established; they are very good and come at an affordable price.

Shape
The most common shape for artist's brushes is round, because it holds more paint and retains water better; with their fine point, round brushes make it possible to create both fine lines and patches. Using flat brushes of medium and large size it is easier to cover broad areas with color and superimpose lines by controlling the pressure applied to the support. Others have a square or a filbert shape, but they are used less commonly than round and flat brushes. Fan brushes produce hatching effects and make it possible to create unique, special strokes.

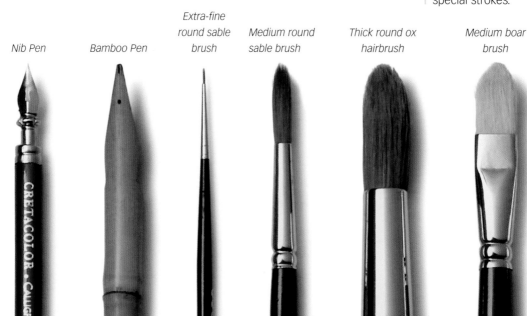

Nib Pen · Bamboo Pen · Extra-fine round sable brush · Medium round sable brush · Thick round ox hairbrush · Medium boar brush · Broad, flat synthetic brush

The applicator *par excellence* for watercolor is a soft, round brush made from animal or synthetic hair. The type of hair affects the quality of the brush, but it is the use that determines the need. It may be appropriate to use flat or round, fine or thick, soft or stiff brushes, depending on the effect desired. It is absolutely standard to use some alternative applicators such as sash brushes, sponges, nib pens, and bamboo pens.

Numbering
Every brush has a number on the handle that indicates its size. Since there is no standardized system, each manufacturer has its own code. Even though the numbering systems are not consistent with one another, the lowest numbers correspond to the finest brushes, and the highest numbers with the thicker brushes.

Sash Brushes
They have a short, thick handle; their shape is flat and broader than that of artist's brushes, and they are sold in various sizes. They are necessary and indispensable for large format works; they make it possible to spread out broad, even washes, and to create large, broad strokes. The ones made with synthetic hair (nylon, toray, taklon, etc.) have elastic fibers that guarantee excellent results.

Sponges
These are very commonly used with aqueous mediums, and specifically with watercolor. They are ideal for their great capacity for absorption and for their softness. The shape is of no importance, since it is a good idea to tear them into pieces suited to the size of the artist's hand to create good control. They are used to produce homogeneous washes, modulated and graded strokes, moistening the paper, diluting the color, opening up clear areas, and erasing color. They may be natural or synthetic. Natural sponges have an irregular shape; they are softer, they hold more water, and they do not damage the paper. Synthetic sponges commonly have a square or round shape; they are stiffer and rougher, and they don't hold as much water. There are sponges with a handle in round or flat shape and of different widths. The flat ones have a stabilizer inside that helps them keep their shape. They spread the color easily and are ideal for creating smooth, graded strokes.

Nib Pens and Bamboo Pens
These are rigid applicators that allow making very fine lines and hatching. They are moistened in liquid watercolor or in regular watercolor thinned with ox gall. They hold the liquid by means of an inner groove. In the bamboo pen it is the natural hollow from the plant, and in the nib pens, it is the metal cavity or a fold designed to hold the liquid. There is a huge variety of shapes and widths. Nib pens and handles can be interchanged.

Synthetic pointed round brush

Fan brush

Synthetic sash brush

Flat sponge brush

Basic Techniques

PREPARING THE PAPER

The cellulose of the paper has hygroscopic properties; that is, it retains water, and as a result, it distorts. In order to control this capacity for retaining water and the consequent movements in the fiber, it is essential to work with heavyweight papers (140 pounds per ream / 300 gsm at a minimum), although it is nearly impossible to entirely eliminate the warping of the paper unless you work with small formats or stretch the paper very tightly in advance.

Controlling the Sizing

Although it is possible to increase the degree of sizing in a paper with synthetic, animal, or cellulose glues, it is impossible to reduce the sizing in the pulp—although it can be done on surface sizing. To do this you merely need to moisten the paper and let it dry before painting; that way any glue on the surface dissolves and the color penetrates deeper into the fiber. On cardboards, hard, or excessively sized papers, it is appropriate to apply a preliminary coat of ox gall thinned with water to increase the permeability of the fiber.

The level of sizing also affects the reversibility of the work. The greater the penetration of the color into the fiber, the more difficult it is to make corrections. Nowadays, the sizings in paper for watercolor are very well-balanced, which facilitates corrections; the sizings in handmade papers depend on the artisan and require preliminary tests by the artist. The preparation of lifting medium, which is initially applied to the paper, allows opening up clear areas with water very easily, and even completely correcting the work.

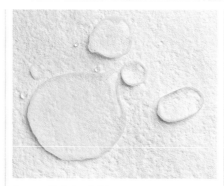

Paper with lots of sizing.
It takes a while for the water to penetrate the fibers.

Paper with little sizing.
The water penetrates the fibers quickly.

Stretching

The fibers of the paper move with the water: when moist they increase in size, and they contract upon drying; this produces warping in the paper and small size variations. To completely control these changes the painter stretches the paper, namely by taping the sides to a board; that way it recovers its stability when it dries. If the paper is of light weight, this is nearly essential to avoid buckling. In these cases, it is a good idea to moisten the paper first and then tape it to the board while it is still damp; with a sized masking tape the stretching effect is greater. However, the most common method is to first attach the paper dry using masking tape, then moisten it, and then let it dry and stretch it more, or else work directly onto the stretched paper just as it is. It is also possible to attach the moist paper onto a frame for canvas, using thumbtacks or staples on the back; when it is dry, the paper is once again tight as a drum.

Paper taped to a board with masking tape.

enerally speaking, watercolor techniques refer to three factors: the support, moisture control, and the manner in which the strokes and textures are created. We must learn to select the paper according to its weight, texture, and sizing, and to prepare it for subsequent work either dry or moist. It is basic to try the measures on this dry or moist support and in various degrees of dissolution and charges on the brush, as well as observing how the paint responds with other agents and substances. Finally, we must have the courage to experiment using color areas or lines, with a mind open to the surprise of something new.

Working on Dry Paper

When working on dry paper, the color takes on greater or lesser depths and sheen as a function of the sizing and the texture. If the paper has a balanced sizing, the color penetrates gradually, so that over several seconds we see the paint remain fresh and brilliant, so we can blend color, create gradations, and so forth. If there is a lot of sizing, this time lengthens to a minute or more, and the result is pooling, which may be a problem or an advantage, depending on the effect desired. On the other hand, when there is very little sizing, the paper absorbs the colors rapidly and mixes them directly. The liveliness and the luminosity of the color are greater with a balanced sizing, since the pigment penetrates into the fiber and still remains on the surface. With a lack of sizing, the color precipitates into the fiber and fades slightly; with too much, the pigment stagnates and the color becomes denser.

With respect to texture, working dry highlights the grain of the paper for two reasons: because the brushstroke emphasizes the relief, and because the color is affected at the level of perception. Thus, satin or fine-grained papers give the color greater luminosity and are ideal for subtle, delicate works, whereas papers with a medium or coarse grain produce the opposite: less luminosity but greater depth; they are ideal for more expressive works.

Working on Wet Paper

When the paper is wet, the paint spreads through the fibers by capillary action. Normally, the mere fact of moistening the paper dissolves the surface sizing, which avoids pooling—unless it is only partially or lightly moistened—and it helps the color to penetrate. If the paper is heavily sized, the color extends over the surface, gaining chromatic intensity and creating contrasting gradations; if there is little sizing, it precipitates quickly toward the interior, losing intensity and light, and a blended halo is created around the stroke. When the paper has a balanced sizing, the color spreads on the surface and in depth, preserving the uniformity of the color and creating much smoother, natural gradations.

Dry Papers *Moist papers*

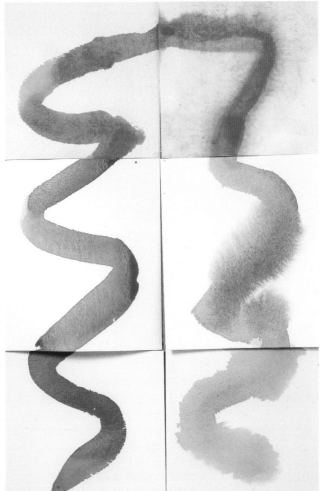

Paper with little sizing and a coarse grain.

Paper with lots of sizing and a fine grain.

Paper with medium sizing and a medium grain.

Basic Techniques

CONTROLLING THE WATER

The main character of watercolor is its deliquescence, in other words, its aqueous appearance of greater or lesser density. That deliquescence means the formation of attractive effects proper to water: gradations, dispersions or precipitations of the pigment, random shapes created through pooling, transparencies, and glazes. In order to exploit these possibilities to the maximum, it is essential to control the moistness of the paper, the amount of water and the color in the stroke, as well as experimenting with different mediums.

Dry on Dry
Watercolor is a wet technique, but if you work with a dry brush, that is, with a small charge, it creates coarser effects. This manner of working is a type of negation of the nature of watercolor, since the final appearance moves away from the magic of liquid, but it is very useful when a dramatic, textural effect is sought. The dry brush highlights the texture of the paper, since the stroke leaves a porous trail. Combined with other wetter effects, it enriches the

Stroke on dry with a lightly loaded brush or "dry brush."

plastic discourse by creating texture and contrast.

Wet on Dry
Working on dry means that the layer of color has lost all moistness and dried completely; this involves waiting several minutes and sometimes a long time if the load of water was excessive. Many painters make use of a hair drier to shorten the drying time; they hold it a minimum of about eight inches (20 cm) from the paper to avoid blowing the

On patches that have dried, the colors do not blend with one another and the brushstrokes are precise and clearly outlined.

pigment with the air, and preferably mixed with cold air.

Wet patches over dry color create a glaze effect through the transparency that characterizes watercolor: The colors mix optically without blending, like transparent colored panes of glass, simultaneously gaining depth and light. With this technique it is not appropriate to rub much with the brush or create areas of standing water, since the dry layer inevitably becomes wet and the colors cloud, creating undesirable light spots with the pigment dispersed in the edges. If you want to work with lots of water on the dry layer, it is preferable to use an aerosol protector to fix the color.

Wet on Wet
Before the layer of color has dried, as we paint, the colors that are added blend with the ones that are drying. This mixing is greater or lesser depending on the extent to which the lower layers have dried, the amount of water in the upper ones, and the insistence of the brushstroke.

Dispersion of color on the still-wet color patches. The colors disperse and blend in smooth, atmospheric gradations.

Standing color. On top of heavily pooled patches of color, the colors do not tend to blend, but rather to create random shapes.

The moment of drying in the lower layer is crucial. On a slightly moist color, the patch retains its shade without mixing, but it loses uniformity, creating blurred outlines or sometimes rings of pigment. If the color is still very wet, a mixing is almost inevitable and the resulting textural effect will depend on the

combination of pigments and the insistence of the brushstroke. If the color pools, random shapes are created, since the pigment disperses into the air or concentrates—inside the patch or at the edges—creating contrasting rings. Regarding the charge of water for interventions on wet, it is important to

Direct mixing. Mixing wet on wet. The brush is used to control the mixes.

keep the following in mind: With little water and lots of pigment, the latter disperses in the moisture beneath; with a balanced proportion of water and pigment, it blends; and with an excess of water, light areas open up and rings of pigment are created. With respect to the insistence of the brush, it is appropriate to mention that with very moderate interventions suggestive effects are created, but in excess the color gets muddied and the image disappears. The brush is also used to achieve color gradations from saturations in one area to another by means of smooth, uniform strokes with clean water.

Gradation of yellow created by diluting the color with water.

Opening Up Light Areas

Watercolor is reputed to be irreversible, but that is not entirely true. If the moistness of the color is retained, it is easy to correct errors and to recover the light from the white paper.

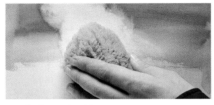

Precisely wash with a wet sponge to open up a light area.

The way to open up light areas is to apply clean water, whether with the brush, a sponge, or straight under the faucet, if you want to restructure the whole work. When the paper is previously prepared with lifting medium, it is even easier. A rag or a paper towel is also very useful for removing excess water or color.

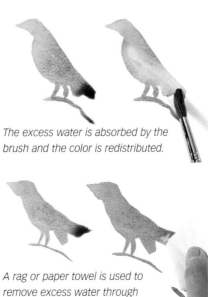

The excess water is absorbed by the brush and the color is redistributed.

A rag or paper towel is used to remove excess water through capillary action.

The Deliquescence of Color

In order to boost the moistness of the color, ox gall is added to the paint or to the pot water, and to lengthen the drying time gum arabic or blending medium is added. The traditional "watercolor medium" is ideal for fulfilling the two functions: moisturizing and retarding.

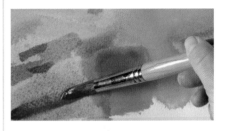

With ox gall, the color stays wet longer and the area blends easily in a uniform, dense manner.

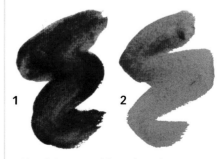

1 **2**

*With a little gum arabic (**1**) the color becomes more brilliant and takes on more body; but if a lot of gum is added (**2**) the transparency increases, it loses purity, and the texture becomes gelatinous, allowing it to form small bubbles.*

Basic Techniques

STROKES

There are four factors involved in making strokes: the applicator selected, its intensity, which is related to the charge of the applicator, its speed, and finally, the modulation that we impart to the stroke.

One fundamental aspect that many painters forget, and because of which their work requires excessive touching up, is that water by itself also creates surprising results. Accidental splashes, drops, puddles, clear spots, and rings are also uncontrolled strokes that bring naturalness and magic to the scene.

Modulated Strokes

The modulation of a stroke is determined by the pressure and the movement of the applicator. A stroke may be sinuous, tremulous, stiff, intermittent, mechanical, hazy, the result of impacts, and so forth. There are as many types of modulation as there are artists, since this aspect is the author's personal calligraphy and determines part of the style. To enrich the personal idiom it is necessary to change the applicator frequently and vary the movements of the hand.

Modulation with sponge brush.

Modulation of brush stroke.

Lines and Hatching

The spontaneity of watercolor and its ephemeral, immaterial nature mean that as a general rule the initial sketch is preserved to the end, which adds naturalness to the work. Linear watercolor strokes commonly have the character of a drawing, and they are connected to the initial structuring or to subsequent drawing that defines outlines and limits. This characteristic requires using applicators appropriate to drawing, such as nib pens or bamboo pens, or other similar watercolor mediums such as pencil, marker, crayons, and soluble pastels.

Lines and hatching done with a brush.

Line from a watercolor marker. In passing the moistened brush over it, watercolor effects are created.

Hatchings are areas that are created through an accumulation of lines. They may be reticular or more gestural, depending on the degree to which their structure is ordered and regular. To create lines and hatching with a nib or bamboo pen, it is appropriate to thin the color with ox gall to moisturize the paint and avoid lumps. The lines in pencil, pastel, or watercolor crayon are more or less soluble depending on how soft or hard they are (with little or lots of binder in their composition, respectively).

Wash of watercolor crayon of medium hardness.

To trace lines and hatching with a nib or bamboo pen, it is appropriate to mix the watercolor with ox gall.

Stroke on wet using very soft watercolor crayon.

Hard watercolor crayon; work done on wet.

Hatching done with a lightly charged synthetic sash brush without pressing down.

Strokes made with a bamboo pen.

Patches

In patches the deliquescence of color becomes especially apparent, since the water can create its characteristic effects when it is spread out. In addition to the patches of uniform colored glazes created with transparency through wet on dry, atmospheric glazes are very common. They are highly diluted layers of color applied generally over the image, whether already dry or still a little wet, without moving the applicator excessively in order to avoid blurring the work. A wash involves holding the watercolor under the water to erode and dilute the image by eliminating pigment. Specifically, the work is held under the faucet, controlling the pressure and the time, or it is put into a tray and gone over with a sponge or a brush to remove color. We can also experiment with splashes, drops, or sprays on the color with a toothbrush. Finally, pools are intentional accumulations of standing water in which the color is deposited to form rings, shapes, and precipitations.

Splash or spray from about a foot (30 cm) from the paper by passing the handle of a paintbrush over the bristles of a toothbrush charged with paint.

Drops of color produced by passing a brush highly charged with paint over the paper.

Atmospheric yellow glaze applied with a sash brush over patches that are still wet in order to create a blurred, hazy effect.

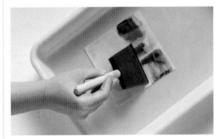

A wash being done in a tray.

Puddle of highly diluted blue on patches of natural sienna. The dark rings are the result of the accumulation of blue and sienna pigments that the water causes at the edges.

Very abundant puddle of water on which very thick color has been deposited right from the tube, which produces precipitations and clots of pigment.

Basic Techniques

CREATING EFFECTS

Many visual effects are created through the use of other similar or extraneous substances. Before applying these technical resources, it is necessary to do some preliminary tests and to observe the reaction of the materials according to the amount used and the action time.

Textural Effects

Watercolor patches naturally tend to contain rich textural nuances. The gradations, dispersions, and flocculations are the result of the behavior of the pigment in the water, and that is one of the most specific aspects of this medium, which invites experimentation by adding external agents to create new textures.

Cobalt dryer is mixed with the watercolor to form patches with open pores and hard burrs. Very similar effects can be created with essence of turpentine.

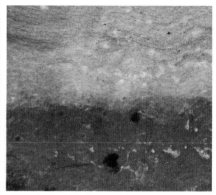

A combination of texture medium and iridescent medium. The texture medium creates a sensation of relief, and the iridescent medium adds small particles with a pearly luster.

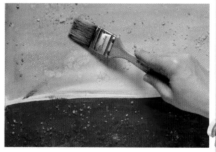

Sea salt is applied on wet watercolor so it absorbs the color and creates star-shaped light areas. Depending on the coarseness of the salt different textures can be created. It is necessary to leave the salt in place and wait for it to dry before removing it with a dry brush.

Aquapasto mixed with watercolor to give the color volume. This medium makes the paint gelatinous.

Gum arabic is whipped energetically with the color to create bubbles in the patch. This effect was used extensively by Egon Schiele.

Alcohol is splashed onto the wet watercolor to create rings of light.

Granulation medium; mixed with color, it produces a sandy texture by creating a granulation with the pigment.

Bleach applied to the wet watercolor to open up light areas using the white of the paper. On dry watercolor it creates clearer, more highly contrasted areas of color.

Reserves

Reserves are areas on the paper that are protected to keep the paint from covering them. This is the way to preserve the white of the paper and its light or the areas of color that you don't want to lose. To reserve an area, a waterproof substance—an oil or a plastic—is usually applied over the area in question. Masks are sold for this purpose, and they may be removable or permanent, depending on the desired effect. Waxes and paraffin, from a candle or a stick of color, are also very useful, but they produce a more textural result.

Removable mask with a thick texture and opaque color. When it dries it forms a totally waterproof film that can be painted. When the work is done, the mask is removed with tweezers, or by rubbing lightly with a dry brush, a rag, or the fingers. It should not be applied with soft or delicate brushes.

White wax to create reserves with a grainy texture. The white of the wax blends in with the paper.

A permanent mask with a fluid, translucent texture; when it dries it becomes transparent. It is applied to the paper to preserve its light to the end, although it is not at all opaque and can be lightly tinted by going over it with color.

White space as a reserve. This is the most natural way to create reserves. White lines and areas are created to reinforce the light as much as possible.

Combined Mediums

Watercolor is a medium that logically can be combined with other aqueous mediums (gouache, acrylic, inks, tempuras), and it also can be very suggestive in combination with dry mediums (pencil, charcoal, pastel), oily mediums (oil paints, crayons), and even with varnishes and enamels. Working creatively with watercolor involves going beyond logical barriers and experimenting with these unusual combinations. When different mediums are combined, their intrinsic characteristics are boosted through pure contrast.

Gold leaf, India ink, and watercolor.

Oil on watercolor.

Gilt enamel, varnish, India ink, and watercolor.

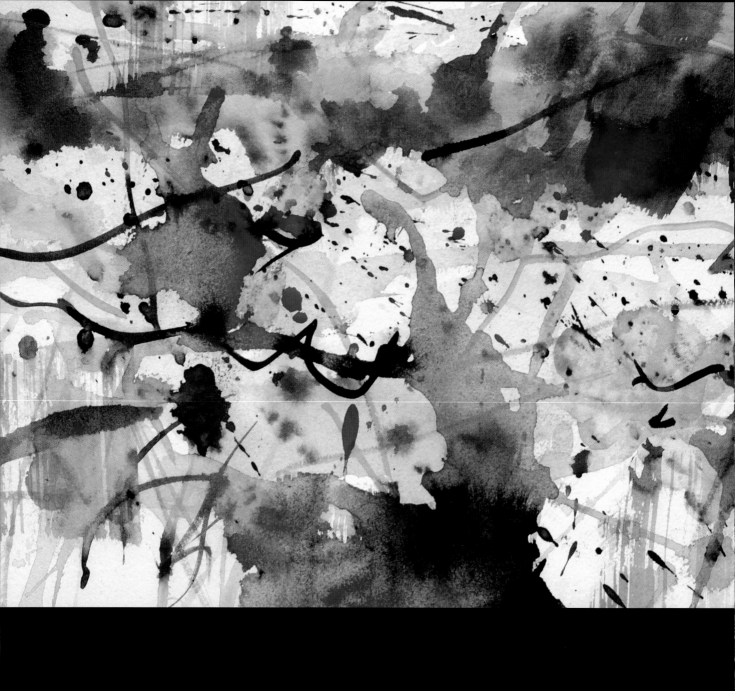

01 **02** **03** **04** **05** **06** **07**

Creative Projects

08 **09** **10** **11** **12** **13** **14**

01 Transparencies
Creative Project

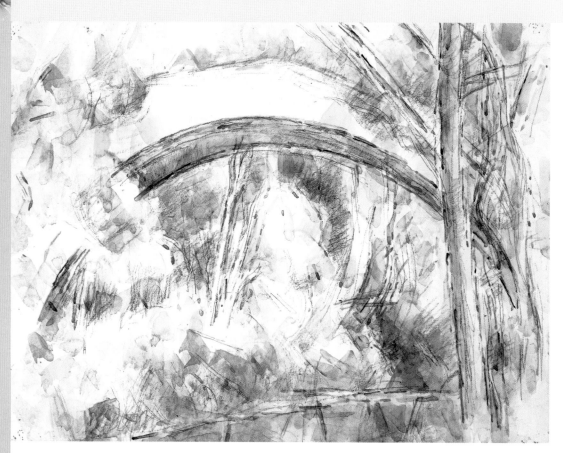

Paul Cézanne
The Bridge of Trois Sautets, 1906.
Cincinnati Art Museum
(Cincinnati, Ohio).

Paul Cézanne (1839–1906) was the first painter who considered the painting to be a living being independent of nature, with an internal logic and language to which he dedicated his entire artistic career. He wanted to contemplate the world anew, through the eyes of a child, without prejudices, and at the same time, produce a solid work worthy of great museums. He invented a method based on patches making up a fabric that defined the bodies without containing them, retaining the spontaneity of the sketch as well as the correctness of the final painting. Starting with chromatic particles conceived in areas of color, he created a whole without hierarchies, distant from the dualism between form and color, thus creating an equivalency between bodies and spaces. The watercolor *The Bridge of Trois Sautets* is one of the last that he painted just before dying. It is done with hundreds of patches of transparent color that allowed him to reach a goal that he had already declared: "When the color reaches its greatest richness, then the shape reaches its fullness." By working in this way, the textures define and dissolve the form. The last watercolors of Cézanne created a major impact and influenced great artists of the time, including Rodin.

Creating Impressions of Color Through Transparencies

The main characteristic of watercolor is its transparency, which invites mixing the colors on the paper by superimposing the patches. This immaterial, magical effect proper to this medium has always been used to boost the luminosity of the color.

In this first creative project, Josep Asunción has taken inspiration from Impressionism in painting a still life using transparent, colored brushstrokes combined with gestural drawing strokes with a pencil, as Cézanne did. This watercolor allows experimenting with the limits between background and the figure, searching for a pictorial whole exempt from a strong hierarchy.

This is the first thing that a painting must offer us, a harmonious quality, an abyss for the gaze to sink into, a dark agitation. A state of chromatic ecstasy … , another world, and yet fully real. This is the miracle. Water is transformed into wine, the world has turned into paint. You sink into the truth of the painting."

Paul Cézanne, quoted by Joachim Gasquet in *Cézanne: What I Saw and What He Told Me,* 1921–1926.

Creating
Stey by Step

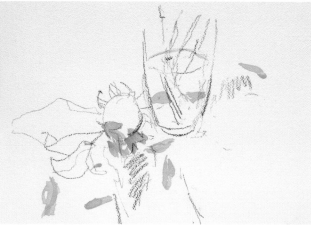

1. We do the drawing with a fairly soft pencil (B) on a watercolor paper of medium grain; the pencil will help us achieve a darker and more expressive line that we will preserve to the end.

Next, using a fine round brush with synthetic hairs, we situate the yellows of the still life by combining brushstrokes of lemon cadmium yellow and dark cadmium yellow.

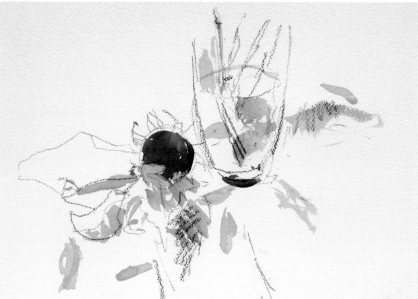

2. For the dark areas of the composition we use natural umber, a dark color, anticipating that it will be a base onto which we will subsequently situate the other colors, which will darken through transparency.

3. Once the lights and shadows of the floral arrangement are situated, we paint the first background patches. In so doing, we combine various reds (dark cadmium, ruby red, and vermilion) and a cobalt purple. Note how the greenish tonality of the natural umber intensifies through contrast of complementarity (red–green).

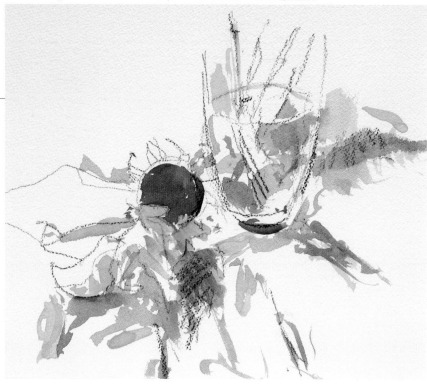

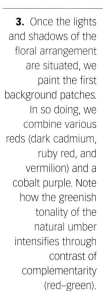

4. We use emerald green and luminous green to define the colors of the stems and the leaves in the still life. Now the chromatic contrast is very intense, which increases the sensation of liveliness in the color.

5. To conclude, we create a general atmosphere with transparencies of purple and vermilion, making the most of the synthetic brush. Since it has a long, very narrow point, we add fine, linear strokes to the leaves and the wrinkles of the tablecloth with light passes. With the brush well charged with paint and applying greater pressure, we create the broad sweeps of the background.

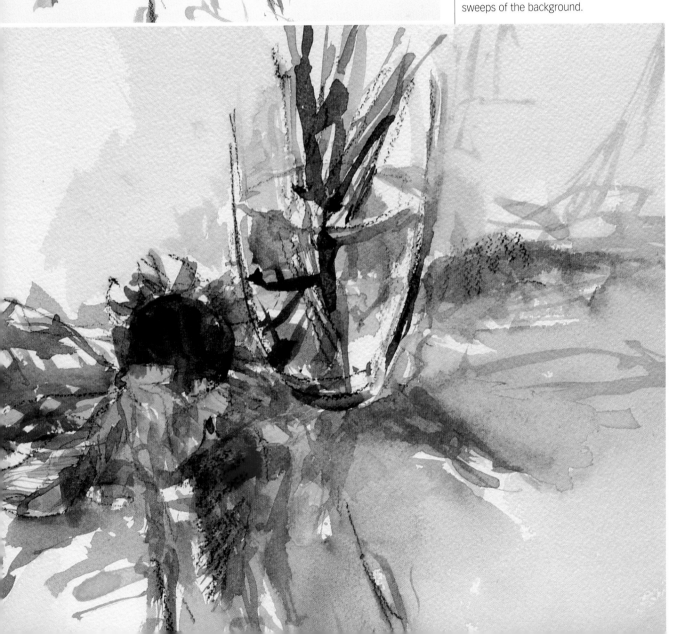

Creative Techniques **Watercolor**

By overlapping transparencies we produce an additive mix of colors. Knowing how to combine the colors of every patch is the key to mastering this language proper to watercolor. In this gallery there are different variations that help us to understand this method.

Transparencies

The focus of this work done on handmade paper is very different, since the intent was to take advantage of the white of the paper by leaving areas unpainted and by applying patches of great transparency with highly diluted color. The effect is very soft and luminous; this is an evanescent and delicate watercolor that takes maximum advantage of the initial drawing done with a stick of graphite (3B).

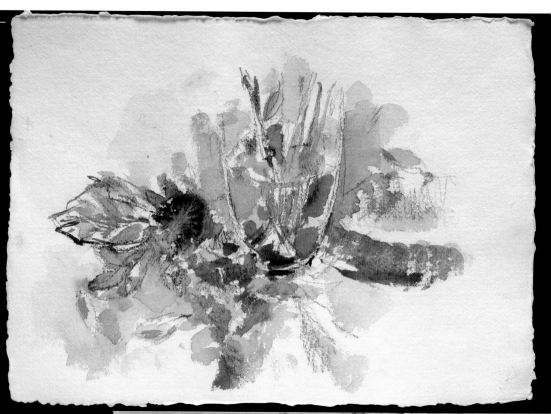

Here is a watercolor done on a general base of uniform colors highly diluted in hues of pink and mauve on a satin watercolor paper. All the colors added subsequently remain bathed in this initial range and none of them has much light, since the white has disappeared almost entirely. The result is atmospheric and very melodious.

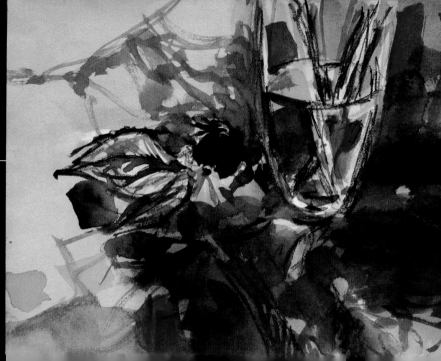

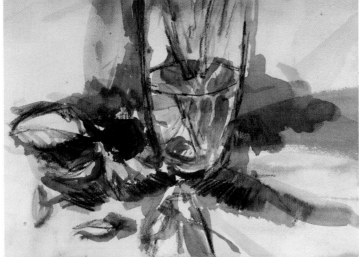

In this example, very clear, uniform patches were created on a fine-grained watercolor paper. Each color was applied diluted with ox gall and the overlapping of colors was tightly controlled to preserve the luminosity of each one. The dark shades were produced by mixing warm and cold patches of pure color. The drawing was completed with pressed charcoal.

01

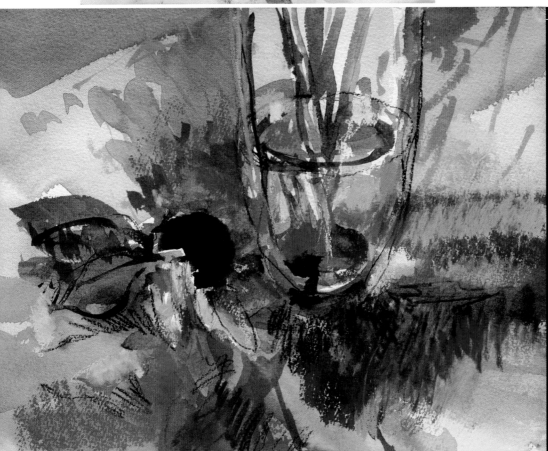

This watercolor, done on medium-grained paper, has several types of transparent patches. On the one hand, broad, highly diluted patches create an atmosphere and a chromatic base; on the other, small patches of more intense watercolor diluted with ox gall; and finally, hatched areas done with sticks of watercolor pastel that combine with the lines of the charcoal drawing. The figure and the background in this example have the same degree of importance.

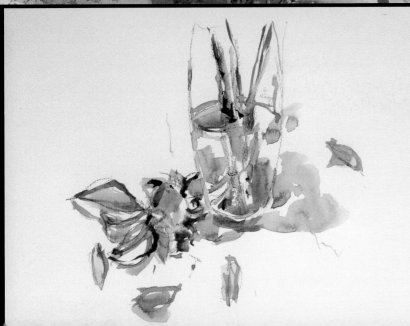

This is the most self-controlled work in the gallery. On it are distributed a few very transparent patches of watercolor diluted with water, revealing the structure of the drawing and much of the white of the fine-grained paper base. The effect is very luminous and clear, with no atmosphere, like that of an overexposed photograph, although we perceive a greater separation between the background and the figure.

01 Window

New
Projects

Another Focus Another way to approach the still life with transparent patches is to intensify to the maximum the chromatic note with highly saturated color, leaving a few light areas so the natural luminosity of the paper can breathe. In this example, we use a bright cadmium red mixed with quinacridone pink.

At no time does the color appear opaque, since it is difficult to attain this effect with watercolor; here most of the colors are very transparent, especially the reds. The most transparent, lively ones are the quinacridone reds, and since the cadmium red fades a little when it dries, it is advisable to mix it with other more stable reds.

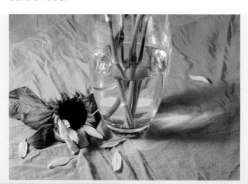

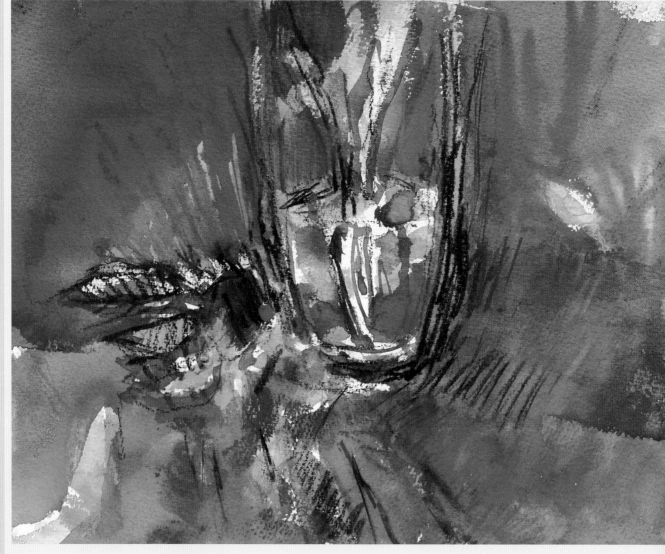

Another Model To distance ourselves from the intimacy of the still life and experiment with open space, Josep Asunción has done a landscape following the same method of juxtaposed, transparent patches. The model is a bridge very similar to the one that Cézanne painted, a subject that sets up an interesting dialogue between the structure of his construction and the freer patches of the vegetation. The drawing was done with a graphite stick (3B) on fine-grained watercolor paper.

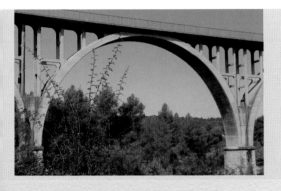

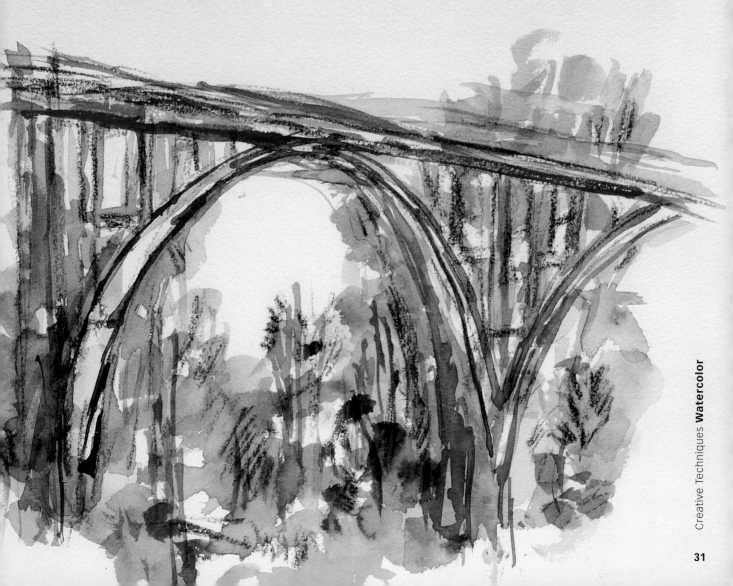

02 Hatching

Creative Project

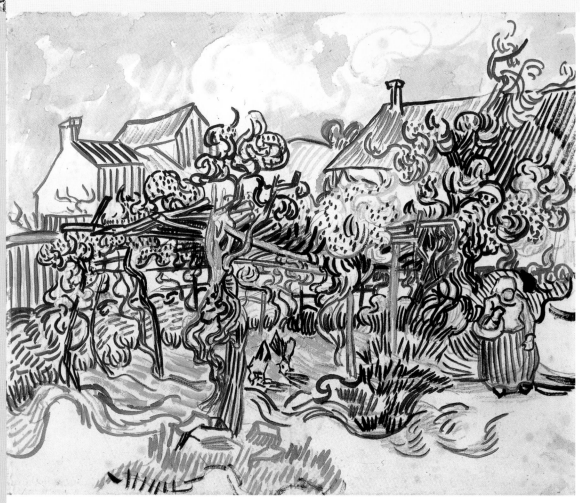

One of the most prominent painters of the second half of the nineteenth century was Vincent van Gogh (1853–1890), who had a language of his own that makes him recognizable for his manner of treating color and shape. His sinuous linear strokes are unmistakable, like a personal calligraphy that is capable of shaping the image like chain mail, creating reticular hatching of great expressive power. Van Gogh was a precursor of expressionist painting because of the direct and vibrant character he imparted to his strokes. In some of his works, it appears that the brushstrokes for spirals of energy moved by an invisible attraction similar to metal threads reacting to magnetism. He painted *en plein air*, motivated by a passion for nature and the search for energy in its pure state, a heritage from Romanticism and Naturalism. Although van Gogh is rarely considered a watercolorist, he expressed himself powerfully in this medium; he did many watercolors using a method based on directional applications of lines of color, as in *Old Vineyard with Woman Walking*, done in the last year of his life.

Vincent van Gogh, *Old Vineyard with Woman Walking*, 1890. Van Gogh Museum (Amsterdam, Netherlands).

Painting Landscapes with Hatching and Linear Strokes

Working with hatching intensifies the immaterial effect of watercolor, since in addition to dealing with a fairly transparent medium, other light areas accumulate: the interlinear space that appears in every hatching. This creative project done by Josep Asunción is based on this effect, and it explores, as van Gogh did, the possibilities it has in representing the natural textures and the topography of the landscape. The applicators are various fine round brushes with synthetic hair, and a bamboo pen and nib pen for calligraphy on a satin watercolor paper. To increase the fluidity of the watercolor and allow good work with nib and bamboo pens, the paint is diluted with ox gall.

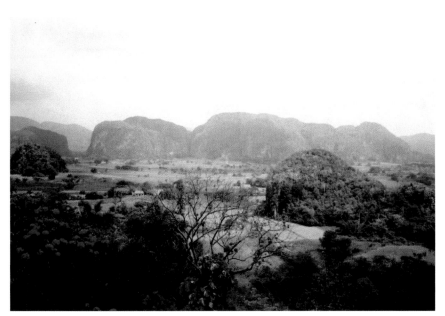

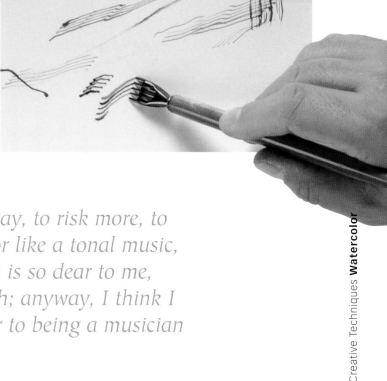

'If I dared to let myself get carried away, to risk more, to leave reality behind and make a color like a tonal music, like certain Monticellis. But the truth is so dear to me, and so is seeking to produce the truth; anyway, I think I prefer to continue being a shoemaker to being a musician with colors."

Van Gogh, *letter to Theo, February 12, 1890.*

Creative Techniques **Watercolor**

Creating
Step by Step

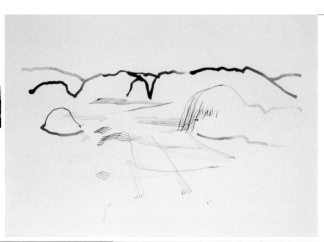

1. Using watercolor thinned with a little ox gall we draw the basic lines of the landscape. We first sketch the intermediate mountains with a bamboo pen and red paint. Then we use a tined nib pen to add the perspective of the field, and a round-pointed nib pen to create the outline of the mountains in the background, all in indigo blue.

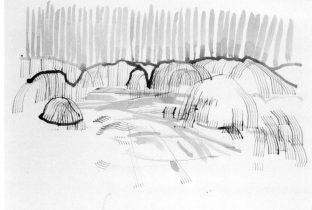

2. With the tined nib pen we add hatched linear strokes that help model and give volume to the mountains. For the sky we choose a hatching that we create with a synthetic brush and light green watercolor. We make the brush lines in the sky touch the still-wet outline of the mountains; that way we create smooth color gradations inside the lines.

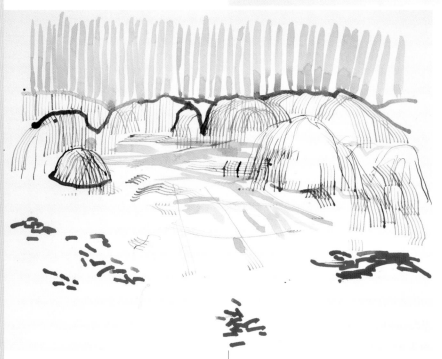

3. We go back to restore the reds by using a round-point nib pen to apply the touches of intense color for the flowers in the foreground and the small hill near the viewpoint. The intermittent strokes create a non-uniform hatching made up of color impacts.

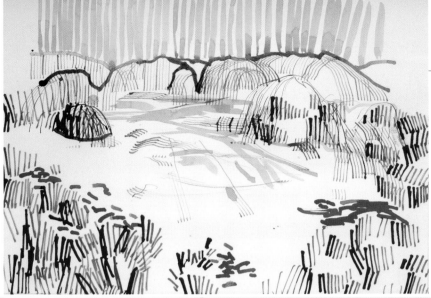

4. The next step involves giving body to the vegetation. Except for the tree in the foreground, which we will leave for the end, the rest of the vegetation is of a general, springy texture and rich in contrasts. We achieve this textural effect of foliage created by trees and bushes through short hatch marks done with the bamboo pen, creating internal gradations, since the color intensity decreases as the bamboo pen loses its pictorial charge.

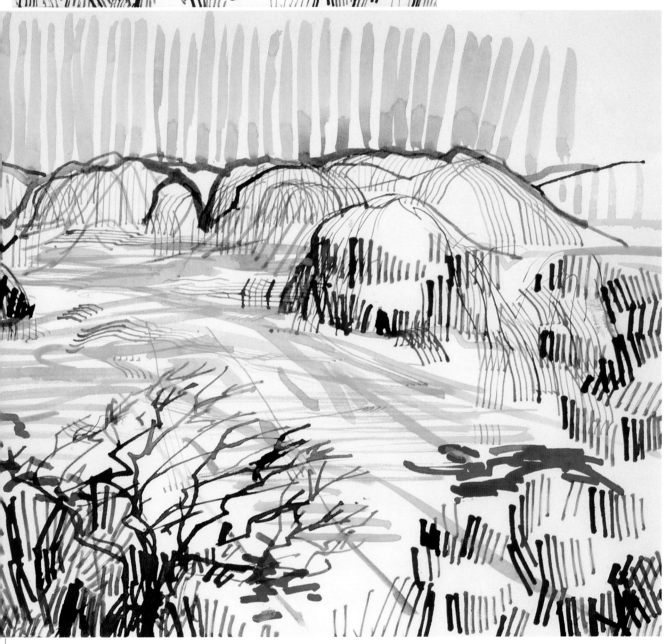

5. To conclude, we paint the tree with a broad nib. We play with the angle of the tip, and with the degree of color dilution we create various greens and thickness of branches. A final hatching in cadmium yellow fills the valley with color and establishes a connection between the nearest and most distant planes of the landscape.

02 Gallery

Other Results

With the hatching technique it is possible to create very clean, fresh results, but also atmospheric, dense finishes. In these pages we see different results from varying the areas of color over which the hatching is applied, as well as the applicator used.

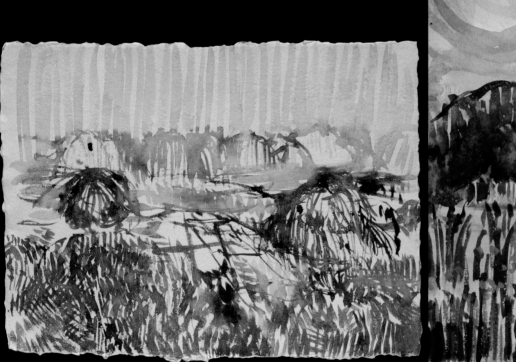

The hatching has been applied with a brush, line by line, onto handmade paper, in a quick, sure manner. The superimposing of green and red strokes has given rise to intermediate brownish and grayish tones. The sense of depth comes from drawing the background hatching with a more diluted color than that of the foreground, thereby creating an atmospheric gradation.

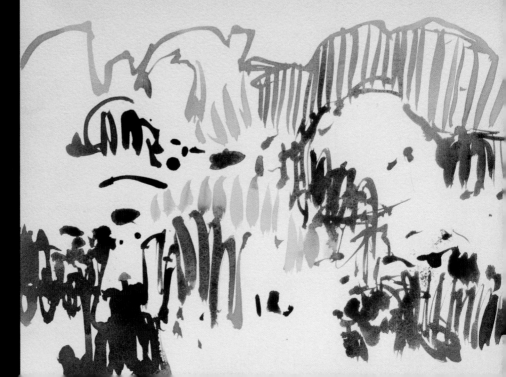

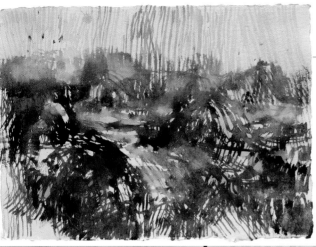

This watercolor painted on fine-grained handmade paper is done entirely with a fan brush, which naturally creates hatching in every stroke. To create dilute, blurry areas of color, some areas of the landscape were previously moistened. As the brush passes over them, the hatching blurs and creates a foggy effect.

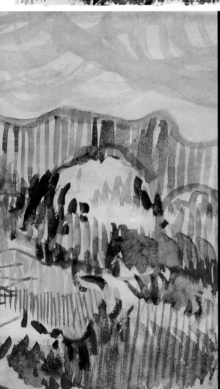

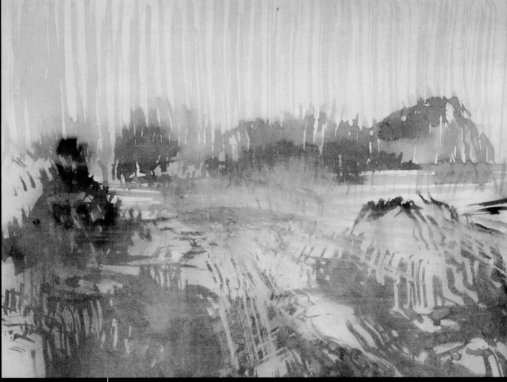

The general atmosphere of this watercolor is determined by the blue hue of the base. On this cold, pale fog there is general hatching of dark blue, as well as other warm areas of hatching that separates the valley from the mountains and the sky. All the work was done using a synthetic brush on a fine-grained watercolor paper.

The eroded effect of this watercolor is due to having been washed a couple of times during its execution. If a wash is applied when a layer of paint is not entirely dry, part of the color comes off and light areas open up—in this case, in the shape of hatching. The moist paper of the wash also causes blended hatching with blurred outlines in subsequent strokes. In this painting a satin watercolor paper, a medium synthetic brush, and a fan brush were used.

This is the most direct and elemental work in the gallery. Its force comes from its quick, extensive creation of hesitation. Every stroke, done with a brush on a fine-grained paper, is a vibrant, energetic line that dialogues with the rest of the lines, following a marked, free rhythm. The color was done in three hues: quinacridone carmine red, Hooker green, and a gray

02 Window

New
Projects

Another Focus In all the works of this project there is a very logical relationship between the hatching and the atmospheres: Lines and patches define spaces, fog, or shapes. To produce a different focus, Josep Asunción wanted to break with this compositional logic and make the hatching and patches dialogue under a greater degree of tension. The watercolor with hues of reds and yellows explains nothing about the landscape—they are simply strokes for effect, such as the squirts and splashes of watercolor in greenish tones. Both watercolors were done on handmade paper.

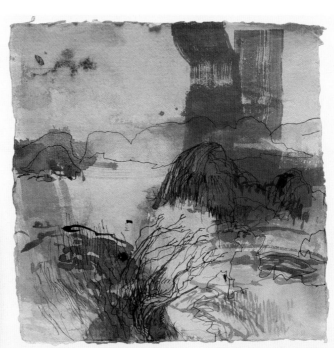

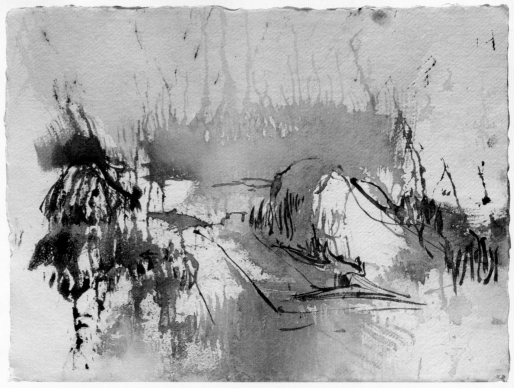

Another Model The previous landscape was panoramic; in contrast, this one, likewise done with hatching, is an enveloping landscape. When we look at an enveloping landscape, there is hardly any perception of the sky, and the sense of depth is produced in closer planes. There is also a greater sense of atmosphere due to the fact that the spectator is located within the landscape, and in front of it. In this watercolor, a melodic scale of warm hues was selected for application over a foggy background in cold gray. The hatching is done with brush and bamboo pen, and the support is a satin paper.

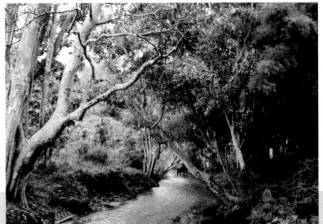

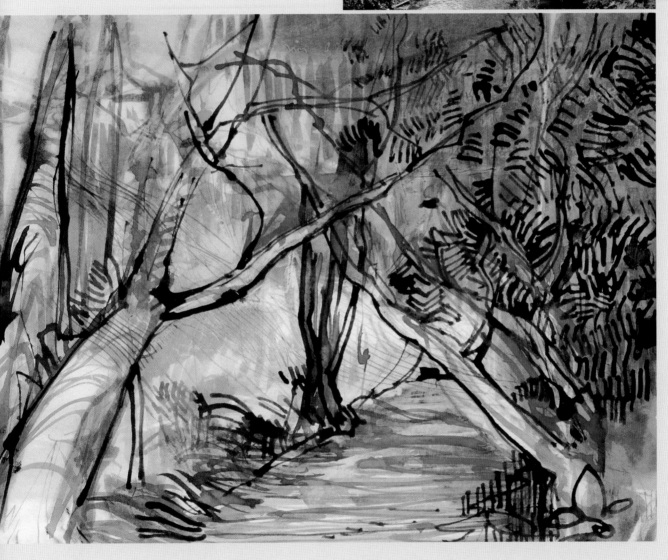

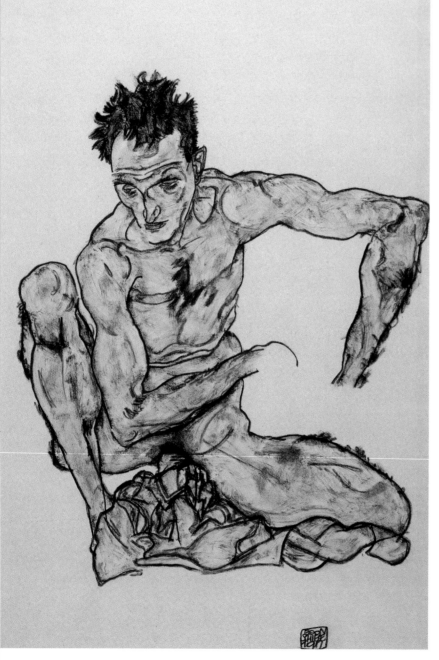

Line and shape are the two basic forms that strokes take. The line is more mental and concrete than the shape, since it describes the form and the limits of space. The shape, on the other hand, is more emotional and sensory; it forms tactile sensations such as the skin or the atmosphere. Egon Schiele (1890–1918) was one of the most expressive painters of Europe at the start of the twentieth century. He excelled for absolute mastery of line and shape and for a certain figurative distortion not devoid of aggressiveness and drama. By means of a cutting, precise line he expressed his own solitude, plus the dramatic dimension of the human being, in the realm of the physical and the moral. In his shapes, color takes on autonomy and becomes charged with textural qualities, especially in his watercolors, such as *Self-Portrait Squatting*, of great tactile effect, which highlights the consequences of an illness from which he was recovering. In order to achieve this textural effect, he added abundant gum arabic to the watercolor and whipped it energetically to create bubbles in the shapes. His linear strokes, on the other hand, were done in chalk or lead, thereby creating a tension between wet and dry. The white backgrounds of his watercolors express a threatening and radical existential void.

Egon Schiele, *Self-Portrait Squatting*, 1916. Grafische Sammlung Albertina (Vienna, Austria).

Defining the Figure by Integrating Line and Shape

Playing with these two realities of the stroke—line and shape—is the purpose of this creative project, which Josep Asunción develops based on a classical theme: Narcissus. The myth of Narcissus expresses very well the duality between the real and the virtual, the concrete and the evanescent, the material and the whimsical. The support for these two watercolors is handmade cotton paper. Technically, in addition to watercolor paint, pencil and sticks of graphite and watercolor pastels are used in creating some lines of color.

'There is no new art. There are new artists. The new artist has to be totally faithful to himself, to be a creator, to be capable of constructing his own foundations directly and alone, without leaning on the past or on tradition ... formula is his antithesis"

Egon Schiele

Creating
Setp by Step

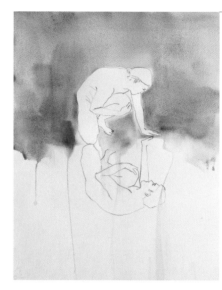

1. We lay out the work by drawing the model twice, in mirror image. We resolve both images neatly and concretely, without formal hesitation. We use a fairly soft graphite pencil (2B) and we bear down a little so we can preserve this drawing to the end.

2. The first colored patches will be the ones in the background, which will have two clearly differentiated areas: the plane of the soil and the plane of the air. Since we want to give a sense of immateriality to the ground plane, which must evoke the sensation of a reflective surface, we give the chromatic density to the air. We lift up the paper with the wet patch to create a few drips that invade the lower area and create the reflection effect.

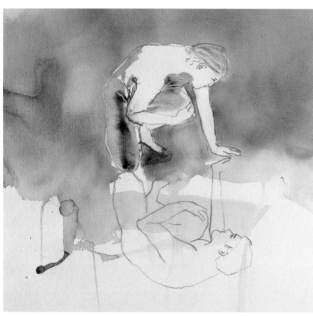

3. With Payne gray we model the major part of Narcissus's body. This is a cold gray that will contrast perfectly with the red. We use the dirty water produced through contact with the two colors to create a transparent, horizontal shape in the reflection of Narcissus. This shape defines the surface, since it is not part of the subject's anatomy, but rather independent of it.

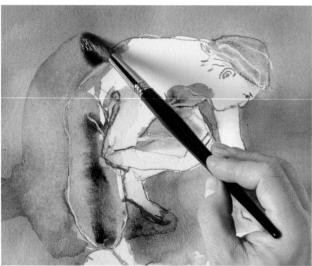

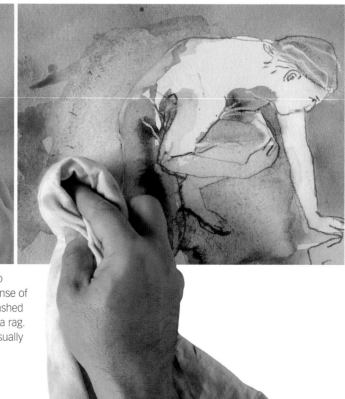

4 and **5.** Next, we apply a wash behind Narcissus, with a view to separating him from the background and giving him a greater sense of volume. To open up this light area, we moisten the area to be washed with clean water, let it sit for a few seconds, and wipe it off with a rag. We use it to slightly cloud the area below the figure to bring it visually closer to the ground.

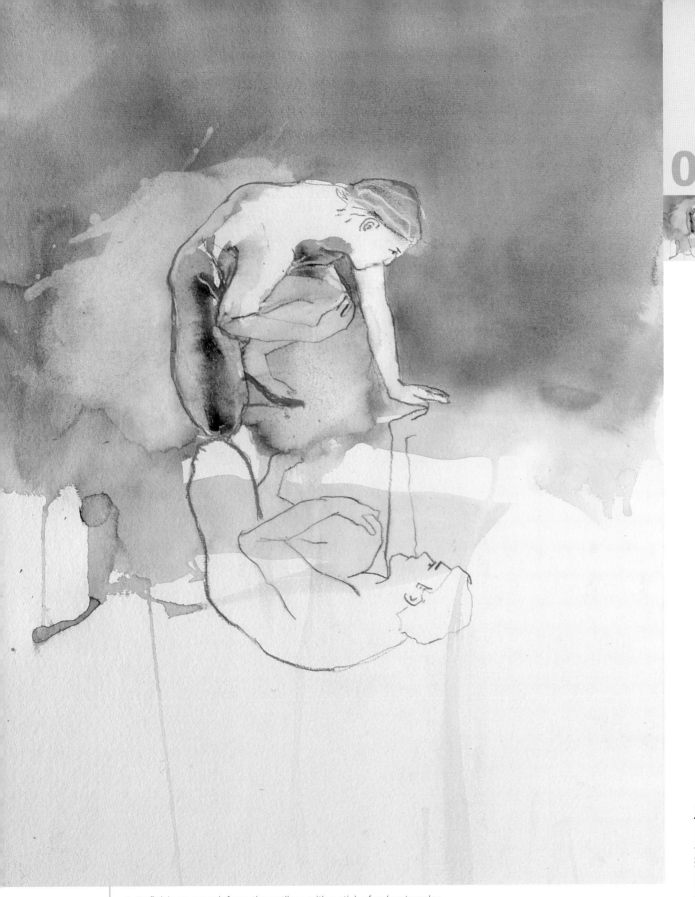

6. To finish up, we reinforce the outlines with a stick of red watercolor pastel. We had previously tried out this possibility with a green linear stroke, but it got lost and offered too little contrast. The final result is very balanced and expressive; the upper part is dominated by the shape and is more sensory and concrete; the lower part is dominated by the line, and it is more mental and virtual.

03 Gallery

Other Results

The following gallery shows different results based on variations in line and patch. By playing with the densities of the patches and their location with respect to the outlines, we create more concrete or more unreal effects. Something comparable happens with the line, and the degree of definition determines the sensation of reality or reflection.

In this watercolor two outline drawings are combined: one done with a white candle and another with a stick of graphite. The drawing with the candle acts as a reserve, so that when we paint on top of it, it preserves a porous, white character from the paper. The red wash acts as a background and a flesh tone for the model, and the green strokes are effects of the reflection done with watercolor pastel. The support is coarse-grained watercolor paper.

In this work, done on handmade paper, we have played with the idea of evanescence. We have treated the two figures with a certain degree of transparency and imprecision. The outlines of the upper figure were drawn with a black watercolor pastel, and this was gone over with an eraser to create a zigzag similar to the one in the reflection in the water; the ones in the lower figure, with a graphite pencil using a fine line.

In this watercolor of neutral hues on handmade cotton paper, there is an absence of reflection, although not totally, since the reflected outlines of the supporting arm and the bended knee are suggested. All the visual weight is located on Narcissus's knee, and the torso and the head are graceful. This change in weight is due to the thickness and the effects of chiaroscuro in the outline, which is done with graphite and watercolor crayons that were gone over with a wet brush.

Here the double image of Narcissus is established like a visual interplay between the imprecise linear outlines made with the sticks of watercolor pastel and the puddles of watercolor in the background. Outline and shape dialogue capriciously and in a dynamism that recalls the reflections in the water of a pool. The support is a coarse-grained watercolor paper.

03

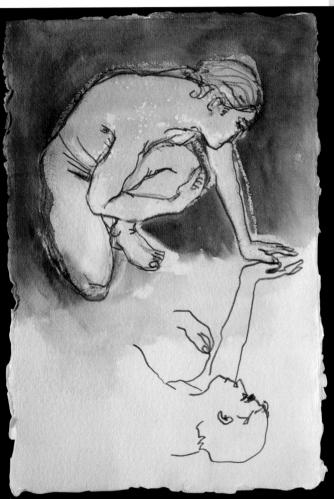

The weight of this work is in the hue of the upper area; the rest of the image is very pale and transparent. The outlines done in graphite pencil (3B) with precise, sure strokes are the elements of greatest definition. The incomplete outline of the lower image denotes virtuality and a reflection instead of corporeal reality. The support is a handmade cotton paper.

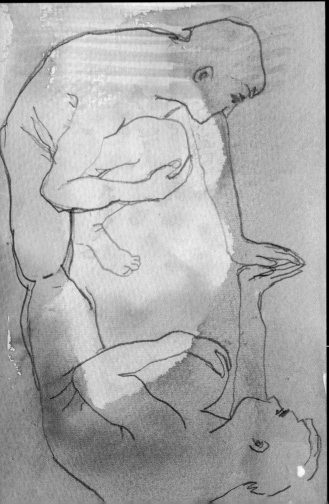

In this example the outline was drawn independently of the shape. A general wash of vermilion and Payne gray was applied to a coarse-grained watercolor paper, and over this the drawing was done with graphite pencil and watercolor pencils once the background was dry. This disconnection between line and shape makes the figures transparent, and both appear as a mental or symbolic image.

Creative Techniques **Watercolor**

45

Another Focus To complete this different focus, we have opted to draw the outlines with a paraffin candle on a piece of handmade paper, and then to use watercolor to paint the shapes around the outline and the figure—in vermilion and Payne gray mixed with indigo blue. The effect is very incorporeal, since the areas of watercolor form a clean gradation that evokes the depth of the space, and the drawing is pure light, since it is made up of a reserve. In addition, there is an interesting interplay between light and dark between the two persons: Narcissus is luminous on the dark area of the background, and his reflection is dark on the light area, whereas his heads and back are transparent. The two figures have weight and grace at the same time. Neither is more real than the other.

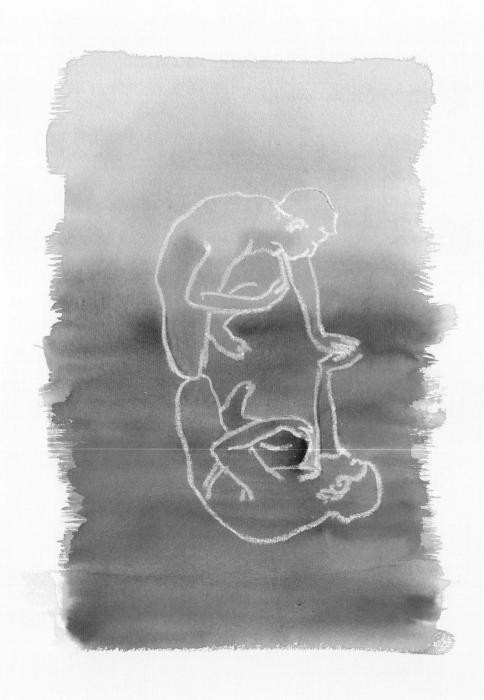

Another Model The outlines of a human figure mark the limits between its mass and space—between the figure and the background—so normally the shape is more important than the modeling of its volume or than the background. To approach this dialogue between line and shape in a different way, Josep Asunción has selected a tree as a model. In a tree, the branches are simultaneously line and body; only the trunk and the main branches have mass, so we find lines that are outlines and lines that are mass. In this case, the line takes on the body, and the shape is the pure effect of light and atmosphere. The runs caused in the lower part picks up the idea of Narcissus, since they act not only as a suggestion of the roots, but also as a reflection of the crown of the tree. The support is a handmade cotton paper of significant weight and size.

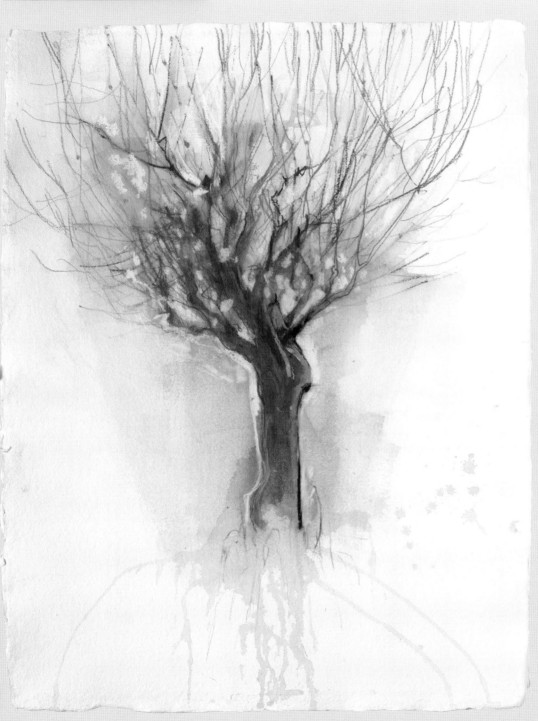

04 Lyricism
Creative Project

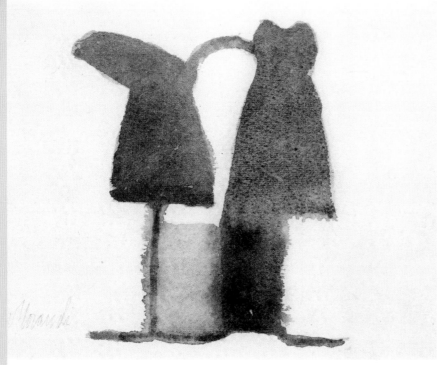

Giorgio Morandi,
Still Life, 1962.
Private collection.

When painters channel and expose their feelings in an indirect, suggestive way, we speak of lyricism. This is what Giorgio Morandi (1890–1964), an introverted, solitary, and timeless painter always did. He lived in seclusion like a monk in his study, even painting some landscapes that he observed from his window with binoculars. But the genre he loved best was still lifes. His models were always the same: He merely changed the position to create a different angle of view, and along with that he changed the light. Little by little he abandoned the line that profiled the shapes to allow planes of color to define space and shape. His palette was always refined and reduced, and his iconography somber. All of this is evident in the watercolors of his final period, such as *Still Life*, from 1962, where he achieved maximum expressiveness by reducing the image to the minimum to arrive nearly at abstraction. The magic of this work resides in its dialogue between the object and the emptiness in which the patches of color, extremely somber and delicate, scarcely suggest the shapes.

Communicating Lyricism and Poetry in an Austere Still Life

A still life made up of small, stacked pieces of white plaster was the model selected by Gemma Guasch. The artist saw in the composition and the austerity of the pieces the principal subject for communicating lyricism and poetry, just as Morandi discovered it in his still lifes.

The austerity of the white plaster allowed her to select the color freely. This creative project was done on fine-grained watercolor paper with a range of warm colors. Round and flat sponge brushes of different widths were used.

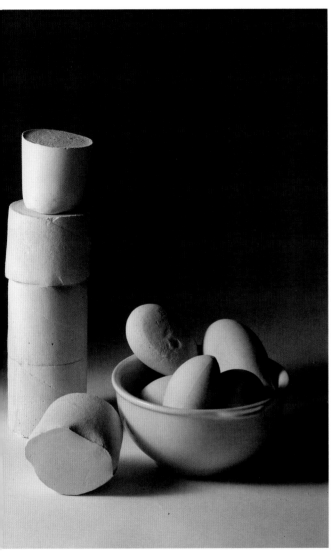

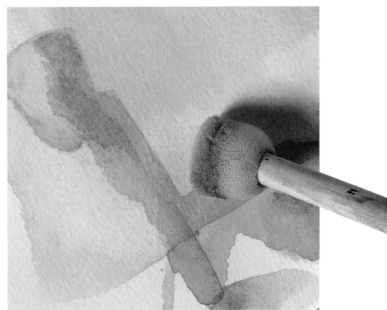

At the instant the jars and bottles affirm themselves before our eyes, their shape surrenders in an atmosphere that decomposes it.

Giorgio Morandi

Creating
Step by Step

1. On a coarse-grained watercolor paper we use a round sponge brush, previously moistened with water, to paint a few dark parts of the still life in iron oxide yellow. We describe the shapes without lifting the brush from the paper and without varying the pressure. We let it dry, and we paint the background with a large patch of the same hue. We control the quantity of water so the color areas do not exceed the limit we have decided to paint.

2. Next, we paint some areas in natural umber. This color helps us create contrast without chromatic pretensions. We let the paper dry a little and apply a wash; for this we submerge the paper in a bucket of water and gently rub it to restore the whites. The wash integrates the shapes, wrapping them in a halo of mystery and softness.

3. The wash has left the paper wet, and before it dries, we incorporate some carmine and purplish hues using a flat sponge brush. The water expands the chromatic range because it varies the intensity of the tones; at the same time, it provides atmosphere because it softens the outlines.

4. Using a sponge, we do a second gentle wash in pink hues and allow it to dry. The wash softens the intensity of the colors and creates a warm, sensual climate. With a flat sponge brush, and without varying the pressure, we paint the empty space as if it were a concrete shape; that way we achieve a homogeneous hue and a compact, flat shape.

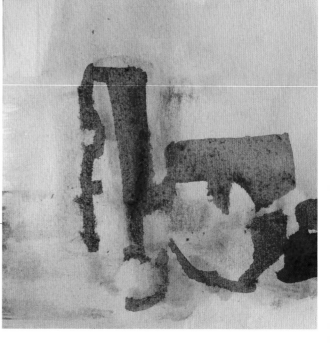

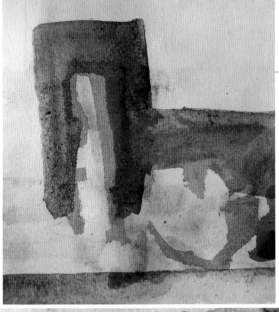

5. To continue along the lines of defining the background as a shape and the still life like a background, we paint in a burnt umber patch that marks out the compositional structure and gives the scene depth.

6. To conclude, we timidly define the outlines of the still life by lightly suggesting the different shapes; we use a small amount of water to control the areas of color more effectively. In the background we accentuate the atmosphere and let the water dilute the outlines and fuse the colors.

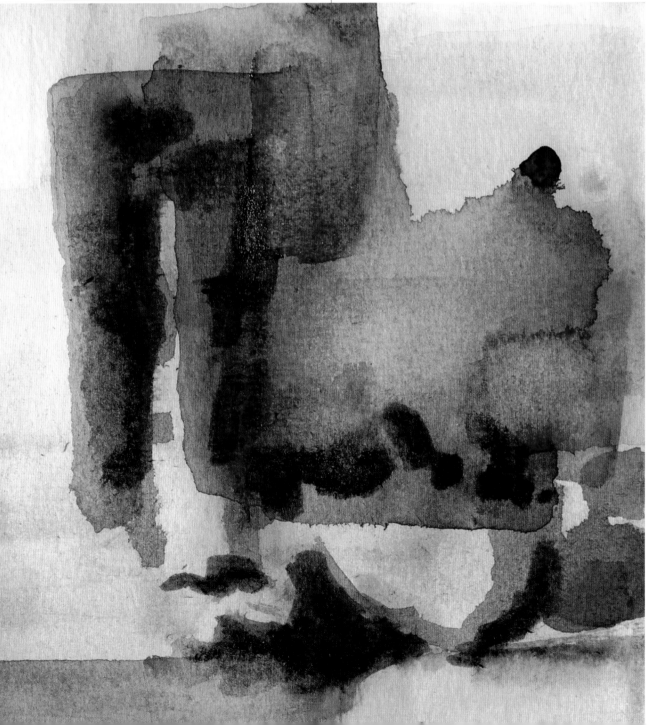

Creative Techniques **Watercolor**

04 Gallery
Other Results

The poetic vision of the shapes responds to the ability to fall in love with details apparently devoid of pretension, and to elevate them to a higher category. Gemma Guasch has based this gallery on this concept. Sometimes she has varied the type of paper or has introduced fine brushes and markers, but she still maintains the warm color range.

This is the most atmospheric and environmental watercolor in the gallery. It is done on satin paper. The atmosphere was created with a succession of superimposed washes, done first with a sponge and partly fused at the outlines with a clean brush moistened only with water.

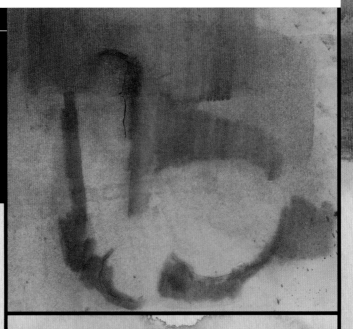

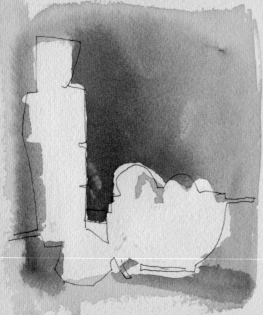

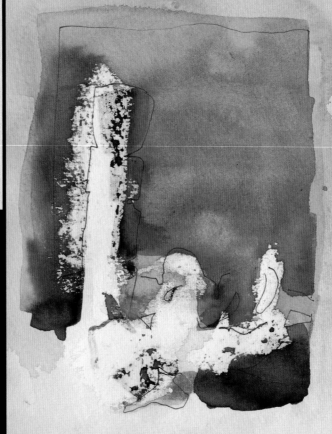

In this work she has opted to work solely on the background and leave the shapes of the still life in white. She has merely outlined the shapes with a black fine-tip marker. To keep the white spots from getting stained, she first set them aside with a mask. The background was painted wet on wet so the hues would fuse slightly and create atmosphere.

A white candle was used to set aside a reserve on a fine-grained paper; then the background was painted in different shades, and once it was dry, the outlines were drawn with a marker. The watercolor did not adhere in the parts covered by the candle. The textured sensation was produced by mixing lean (water) over fat (paraffin).

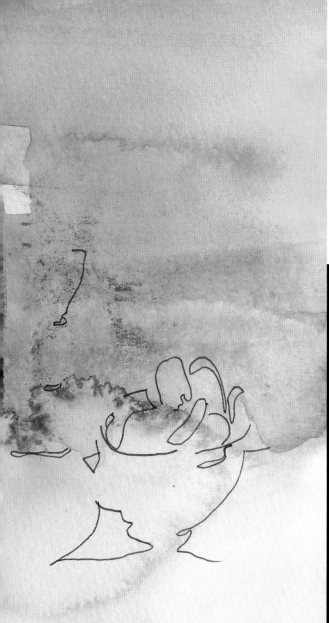

The set of shapes in the still life was conceived in a monolithic manner, showing it like a new, unique shape. It was painted with a flat sponge brush, describing the horizontal borders that have created a flat stroke that contrasts with the atmospheric sensation of each patch.

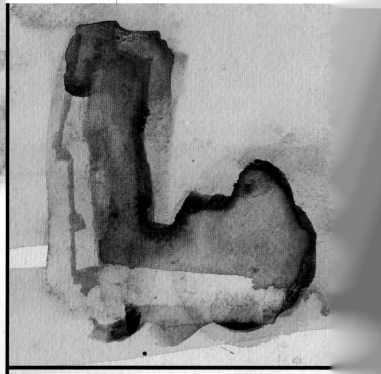

On another watercolor paper also of fine grain, several aggressive washes have been done under the faucet, which have left only slight traces of watercolor. Then it was decided to paint the background, creating atmosphere and slightly suggesting the empty spaces among the shapes. Absence is the lyrical basis for this watercolor.

This watercolor is the cleanest and freshest of the gallery. Like most of them, it was painted on a fine-grained paper. The shapes are outlined with a fine-tip black marker, allowing us to see the silhouette. The color alone defines directly and lightly the parts of shadow without atmospheres or gradations. The poetry comes through because of its simplicity.

Another Focus The lyrical and poetic contribution of the watercolors done previously was achieved through a few minimal, delicate strokes, as well as some soft, controlled atmospheres. To show a different focus, Gemma Guasch has decided to work the still life by searching for a vital, dynamic vision, less delicate and smooth. On a fine-grained paper she first pulverized watercolor with a broad, flat brush and added some splashes; then she painted the strokes with a medium flat brush, leaving the brushstrokes visible, without retouching. Finally, she defined the silhouette of the still life with a thicker line done with a syringe filled with diluted watercolor and a little water, and she let the picture dry flat so the liquid would not run and lose the shapes.

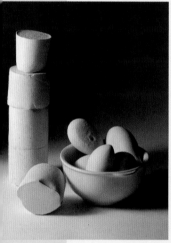

Another Model Again, the model selected in this instance is a still life: oranges and milk in a clear glass vessel. In contrast to the previous one, this model contains color and life since it deals with food, even though the composition is similar in its austerity and simplicity. Its simple, minimalist appearance helps focus the work in a poetic manner. In the first watercolor, painted on fine-grained paper, a clean, fresh line was chosen in order to define each silhouette a little and let some gradated, dynamic shapes vibrate. The second, done on fine-grained heavyweight paper, is dense and environmental; through the lack of definition and the fusion of hues it suggests a certain lyricism.

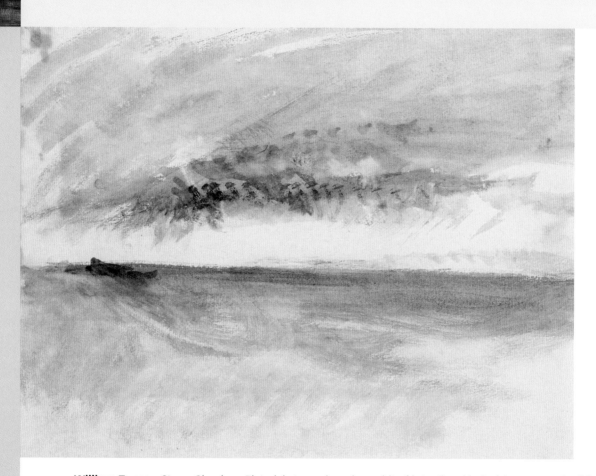

William Turner, *Storm Clouds, Watching the Sea*, 1845. Clore Gallery (London, England).

Pictorial atmosphere has a bit of intentional indecisiveness and sublime torment in the work of the British painter William Turner (1775–1851). This precocious artist, who from the start inclined toward landscape painting, became, along with Constable, an indisputable master of English landscape painting. He never experienced economic difficulties, because from the beginning he had unconditional patrons, such as the third count of Egremont and John Ruskin, which made it possible to travel and broaden his mind. He is known as the painter of light, for throughout his artistic career he became increasingly interested in showing pure light and its atmospheric effects on color. Like a good romantic, he approached the philosophy of the sublime, portraying the astonishing power of nature over humans: Turner painted storms, fire, and all kinds of natural phenomena with a tremendous force and an unbridled passion. At the end of his days, his work was tremendously chaotic; according to one critic of the time, "It appeared that the atmosphere had eaten them up." The watercolor *Storm Clouds, Watching the Sea* reflects the impression of the clouds and the breaking of the waves on a crossing to France on the coast of Normandy with a set idea that he expressed in this way: "watching over the storms and the shipwrecks."

Producing Atmosphere in a Landscape by Means of Glazes and Fades

Watercolor is a very transparent medium that invites the artist to fuse and superimpose colors to produce suggestive atmospheres. Thus, the creator of this work, Gemma Guasch, has chosen a cloudscape. This work has allowed her free investigation into the creation of suggestive glazes and rich fades without being tied to a figurative base. A great variety of brushes were used: synthetic sash brush, flat ox-hair pencil brush, and a fan brush, all soft, which favored the fusion and superposition of colors. The support is a heavyweight watercolor paper, without texture. The chromatic range is appropriate to landscape, emphasizing it to make it more intense and romantic.

'The colors are behind other colors. Through them the true colors take on distance. Everything shines behind another image that we never manage to see."

William Turner

Creating
Step by Step

1. With a synthetic sash brush moistened with plenty of water, we define the sky in lemon cadmium yellow, and the ground in permanent green. We exercise control to keep the color areas homogeneous and clean.

2. Before it dries, we use a flat sponge brush to modulate strokes with vermilion on top of the yellow patches. The strokes with the sponge brush must be done with varied pressure to create dynamic, unequal lines. The water blends the hues freely. It is important to overcome our fear of the medium and allow ourselves to be spontaneous.

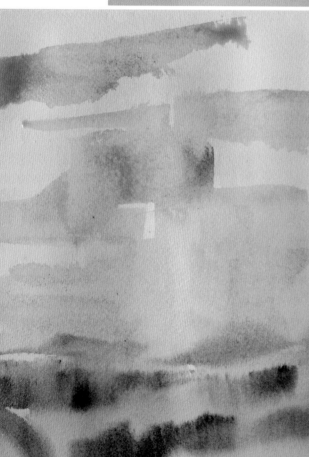

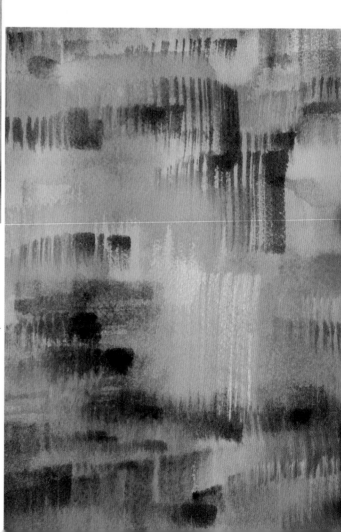

3. With a flat ox-hair pencil brush, and with no intention of defining the landscape excessively, we provide contrast by using a grayish–green wash to create spatial depth. This brush helps us to define and control the strokes.

4. In order to superimpose hues we must allow the watercolor to dry thoroughly so that the colors don't mix, and so we can create atmospheres that allow seeing the previous colors. To create discontinuous lines we have painted them on dry with the synthetic sash brush, using different hues. We painted them in a single pass and without retouching or regret, for otherwise the colors would join and fuse.

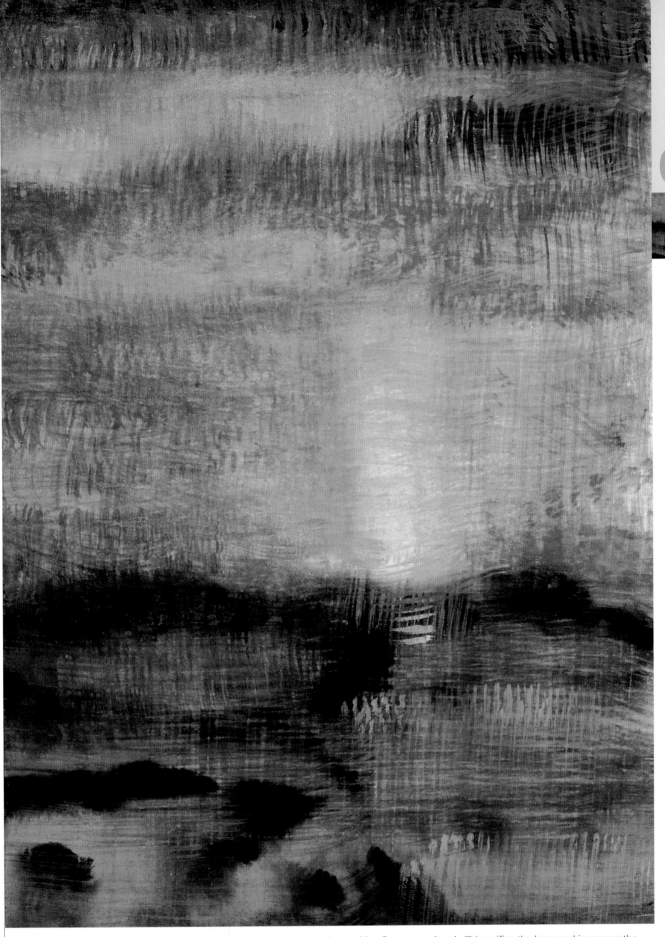

5. Once the patches are dry, we apply a very soft yellow glaze over them with a flat sponge brush. This unifies the hues and increases the atmospheric charge because it makes it denser. To conclude, when the glaze is dry, we use a dry fan brush to make small strokes in Turkish green. These superimposed lines give the landscape depth and light.

Creative Techniques **Watercolor**

05 Gallery
Other Results

The creation of atmospheres by allowing the hues to fuse or by superposing them requires that we work with a constant tension between control and lack of control. This was both the stimulus and the challenge that confronted Gemma Guasch in creating this varied gallery.

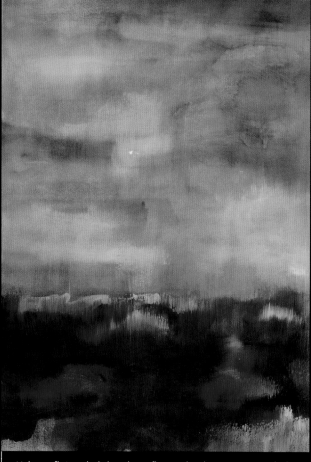

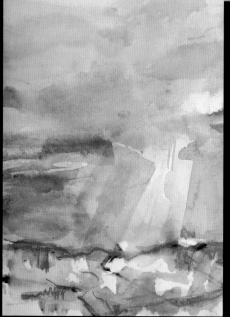

This is a fresh, direct watercolor done with a sponge on a satin watercolor paper. It shows us with contrast and clarity the vertical ray of light from the sky. The rest of the landscape seeks the fusion of the hues and ambiguity without details or retouching, with agile, immediate strokes.

Using a flat ox-hair brush on fine-grained paper, we seek the fusion and the superimposition of hues, thereby producing the densest and most atmospheric watercolor of the gallery. Nearly all the hues contain yellow, which intensifies the life of the landscape. The vanishing of the brushstrokes and the fusion of the colors increase the sensation of atmospheric luminosity.

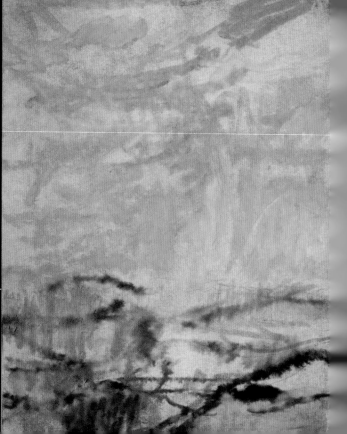

A dynamic, direct watercolor is created from extensive patches of watercolor painted over with sticks of watercolor pastel. The sticks can be blended with the colors by applying water over them, or else they can contribute density if they are not moistened too much. A heavyweight paper was used in this work.

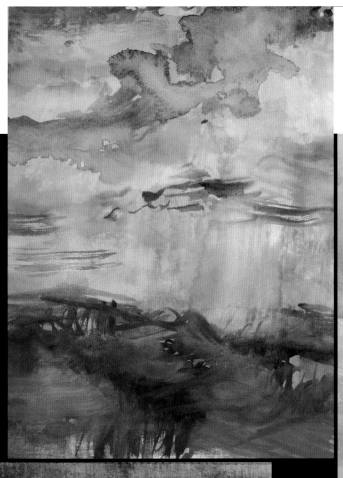

The puddle and the water are the protagonists in this uncontrolled, direct landscape done on fine-grained paper. The puddles of water allow every color to take on shape freely without the use of the brush. These areas were given contrast with light strokes applied on top using a fine round brush to gently define the landscape.

Watercolors allow us to marvel at unfinished paintings with few interventions. This is precisely what was accomplished in this watercolor, painted on a satin paper with a flat sponge brush charged with plenty of water: allowing the luminosity of the yellow partially fused with a warm gray to be sufficient to evoke in us the sensations of warmth and light at dusk.

A naturalistic watercolor is painted on a heavyweight paper with superimposed strokes done with a synthetic sash brush and a flat ox-hair pencil brush. The strokes painted without retouching allow us to see the hues applied previously, as if we were dealing with a work done in layers. The chromatic sobriety and the homogeneity in the strokes create a sedate

05 Window

New
Projects

Another Focus In order to achieve a different focus, we have sought to create an atmosphere based on darkness. First we have bathed the papers, of heavy weight, in dark shades, and then the cloudscape was defined with pure, direct colors on top. Watercolor is a very transparent medium, and the luminous colors on top of the dark ones fade when they dry, so it is necessary to wait for them to dry to evaluate the luminosity and repeat the operation on top until the color stands out. This insistence favors the creation of charged, dense atmospheres. In the first case, the colors were reinforced by applying watercolor crayons on top, and in the second, by painting with a flat sponge brush once the paint was dry. The contrast between the darkness of the background and the pure hues produces a tragic, disturbing sensation.

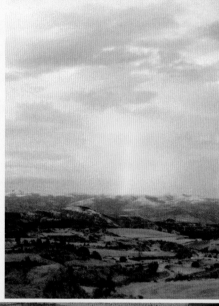

Another Model Without varying the genre, Gemma Guasch wanted to continue working with cloudscapes, since they offer a vision of a changing and dynamic nature. The weather and the light produce constant changes. As a result, here we have chosen a cloudscape of huge, dense clouds ready to empty themselves and water the earth with a powerful storm. The objective is to capture the instant prior to the storm by painting a dense, grayish atmosphere that contrasts with a white, direct light. In the clouds the shades are fused by insisting with superimposed brushstrokes on wet; the beauty of the dense, contrasting white was achieved by directly applying white watercolor from a tube. All of this is done on a fine-grained paper.

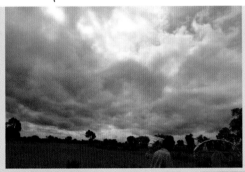

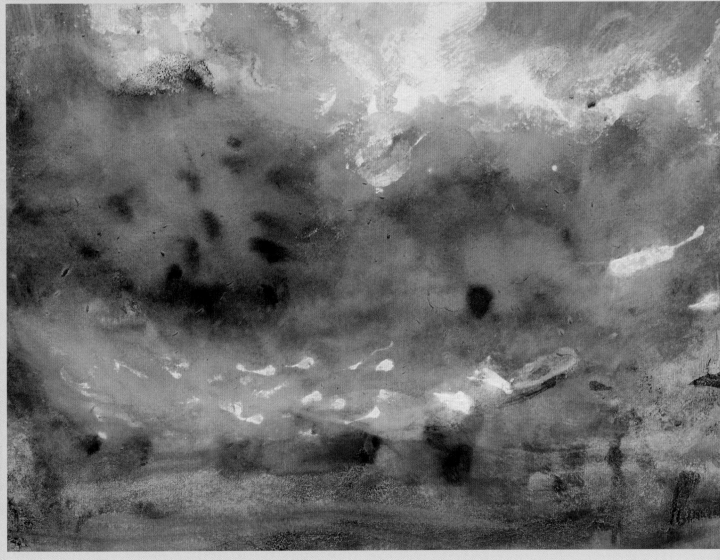

06 Imaginary Spaces
Creative Project

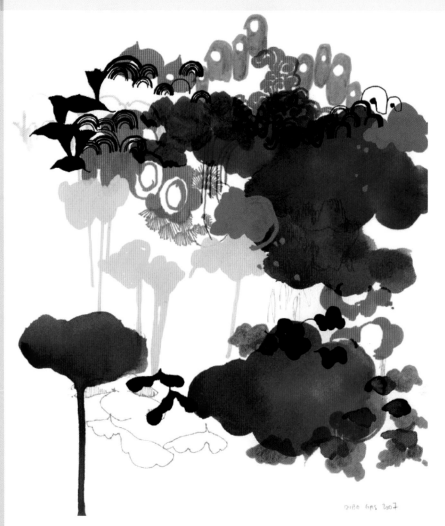

New technologies are evolving quickly, and in them artists see uncharted territory for exploration and research. This is the case of the Qubo Gas Collective, founded in 2000 by Jef Ablezot (born 1976), Morgan Dimnet (1973), and Laura Henno (1976). In their creations, they alternate traditional methods (watercolor on paper, drawings with markers, collage, silkscreen printing, etc.) with computer programming (evolutionary digital drawings and works). The three artists, in Lille, France, emphasize the reciprocity of the two mediums: "The digital work interrogates the graphic work and suggests a concrete process, and vice versa." This reciprocity is also present in the collective's manner of working; the intervention of each member awakens in the others the desire to respond, like in a jam session. Their landscapes, dreamy and imaginative, recall subtle, refined Japanese illustrations. *Gnik Nus* combines delicate patches of watercolor and fine lines. Qubo Gas includes artists of the most recent generation who are close to drawing, illustration, and street art, but who also have a remarkable quality in rescuing the traditional mediums of painting and drawing, as well as watercolor, and placing them far to the forefront of their time.

Qubo Gas,
Gnik Nus, 2007.
Private collection.

Creative Techniques **Watercolor**

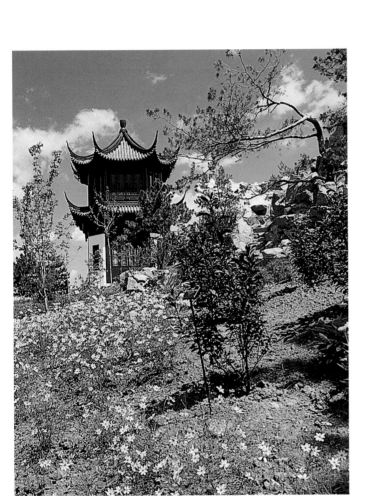

Uniting the Languages of Drawing and Painting to Create Fantastic Landscapes

Humans have always needed to find a space where they can dream, imagine, and fantasize, and art has enabled them to do all of that without restrictions or limits. Creating dreamlike, unreal landscapes filled with color and fantasy has motivated Gemma Guasch to create this project. The inspiration was oriental art, its gardens, temples, and particular vegetation. To do this project, watercolor is mixed with markers and watercolor crayons, allowing the idioms of painting and drawing to influence one another.

The selected support is fine-grained watercolor paper, and there is a large variety of applicators: bamboo pens, round ox-hair and synthetic brushes in different sizes, and round sponge brushes.

"Nature is … in reality the unexhausted mine from which the poet and the painter have extracted such astonishing treasures: a constant fountain of intellectual pleasure, where all can drink, and where there will awaken a deeper sense of the works from the geniuses and a more acute perception of the beauty of our existence."

Thomas Cole, *Essay on the American Stage*, 1836.

Creative Techniques **Watercolor**

Creating Step by Step

1. On a fine-grained watercolor we paint a circle in a hue of quinacridone pink using a fine round ox-hair brush; next to it, the outline of a mountain. From the beginning, the duo of the two forms, circle and line, opens up the work to the realm of fantasy and unreality.

2. We paint another circle in orange on top of the preceding one; then we gently dry it by passing a cotton rag over it to absorb the excess water and produce an effect of erosion. Inside of it we draw a temple using a watercolor marker. Then we paint a circle in carmine, but apart from the preceding one, and we go over the temple with a bamboo pen. Finally, below the mountains we paint on an irregular wash of pink.

3. We do a large wash over the entire paper, in highly diluted yellowish green, using a thick ox-hair brush. Next we draw some tree branches with a watercolor crayon in the same hue and likewise over the entire paper.

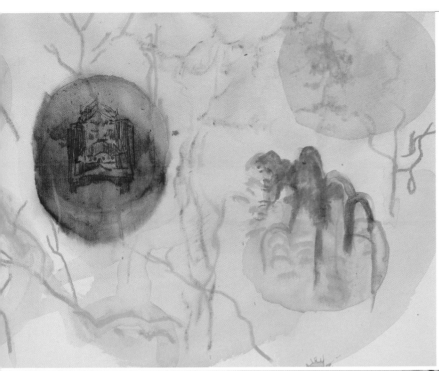

4. To emphasize the exuberance of the light and color, we paint some yellow areas in a circular shape on the paper. Using an orange marker we draw small lines on the mountain and distributed throughout the paper.

5. We complete the work with the representation of the green trees, which we draw with a watercolor crayon, and the outline of the temple, drawn with a very fine line from an orange marker. The final result is a fictitious landscape inspired by oriental art, which brims with freshness, vitality, and light.

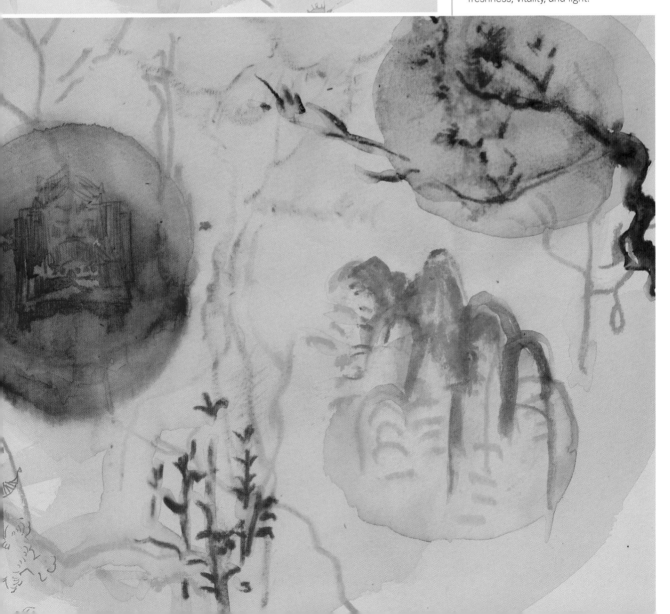

06 Gallery

Other Results

The magic of Japanese prints, the delicate colors of the watercolor, and the fine lines from the marker have inspired Gemma Guasch in this example to paint dreamlike and fantastic landscapes, allowing the imagination to be the main player in this gallery. The supports used run from fine leaves from an antique notebook to drawing papers of heavier weight.

Painted on the leaf using an antique notebook as a guideline, here is a nocturnal landscape with a watercolor background in purple and black shades. Once it was dry, the details were drawn with watercolor crayons in bright colors. The solemnity and sobriety of the background contrasts with the vivacity of the crayons and highlights the details: trees, branches, and mountains.

A quick, energetic line done with a bamboo pen draws a free and gestural structure that recalls oriental calligraphy. The antique notebook leaf is scarcely covered, and in it we see the fine horizontal lines. The areas in blue and dirty pink located at the opposing ends of the

Some dynamic, gestural structures done quickly and energetically with bamboo pen create an agile, directly accessible drawing. The areas of watercolor in quinacridone pink and cerulean blue diluted with water locate the areas of repose and calm. A temple is drawn with a marker on the blue field, and gum arabic has been applied directly over it, thereby restoring transparency and reducing the intensity of the color.

In this watercolor, a bluish and blackish atmosphere bathes nearly the entire notebook sheet. The density of the blacks contrasts with the variety of blues painted by adding more water to the watercolor. This is an ideal background for illumination using white watercolor crayon.

This is the most real landscape in the gallery because of the centered composition of the temple and its white color, which makes it stand out in the middle of the dark background. The magic is due to its construction using superimposed fields and lines that reproduce the landscape several times and allow seeing the previous stage through each intervention.

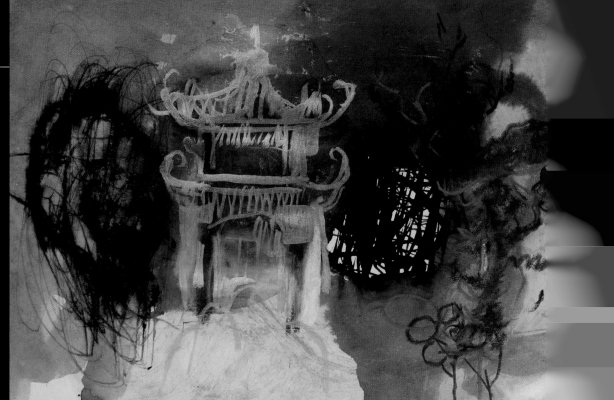

06 Window

New
Projects

Another Focus All of the foregoing projects are in a rectangular format and small size (6 × 10 inches / 15 × 25 cm). Here, in order to vary the focus, the format is modified from rectangular to square, and the size has been increased significantly (24 × 24 inches / 60 × 60 cm). The square shape neutralizes the tension because all sides have identical measurements. The square format has been reinforced by painting centered landscapes, leaving a large margin around them. The landscapes, done on an elegant smooth card stock in beige color, were drawn with crayons and liquid watercolors without creating atmospheres, emphasizing the language of the drawing over the painting.

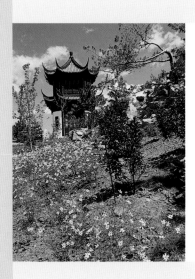

Another Model Representations of fantastic, dreamlike landscapes need no clear references for inspiration; any subject will do if you let your imagination take flight. In this case some river stones were chosen. They get their shape from the quantity of water that wears them away; they are elements that nature transforms constantly. This concept was the inspiration for this composition based on the repetition and the dynamism of two curves: first the one of the whole, and secondly, the roundness of each stone. The painting was done by mixing markers and watercolors, but giving priority to the neatness and transparency characteristic of this medium.

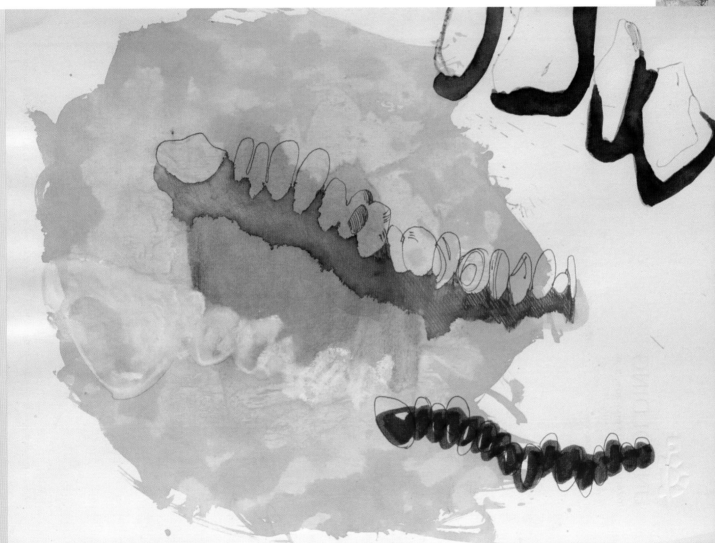

07 Wet on Wet
Creative Project

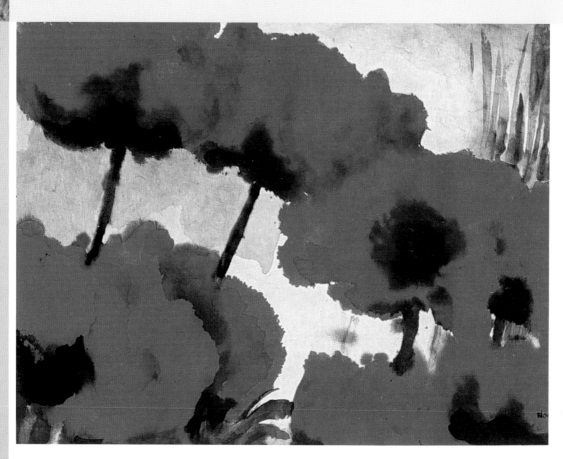

Emil Nolde,
Poppies,
undated.
Private collection.

In the hands of Emil Nolde (1867–1956), watercolor took on a tremendous expressive greatness. Nature was his main source of inspiration. In painting nature, he sought to extract its "soul," by finding its underlying, ancient meaning. He thus took inspiration from the art of primitive populations and immersed himself in a crossing of the south Pacific. He was a member of the expressionist painters *Die Brücke*. He was the oldest person in the group, and everyone admired the security and the confidence he had when he worked. He painted in oil and did numerous woodcuts, but his major successes came from watercolor. It is known that he had knowledge of Chinese wash painting, although he never knew its great secret— how to control the deliquescence of the wet colors—painting wet on wet in his watercolors on Japanese paper. His typically Nordic work stood out for its ardent, solid, and vigorous character. In the watercolor *Poppies*, Nolde showed his skill in mastering the medium and the color, presenting us with a very expressive nature in a pure and exuberant state.

Experimenting with the Deliquescence of Color and its Expressiveness

The possibilities of watercolor worked wet on wet are huge, since it produces multiple effects that you must be able to assess and produce. On a moistened paper, the watercolor is spread out freely in accordance with the quantity of water it contains to form patches and lines. In this creative project, Gemma Guasch has painted some poppies on fine-grained, heavyweight watercolor paper. She has added ox gall to prolong the effects of the moistness and increase the transparency.

Colors, that is the painter's material: colors in his own natural life, crying, laughing. Dream and happiness, warm and sacred, like love songs and like eroticism, like canticles and like magnificent chorales. It is beautiful when the painter, guided by instinct, can paint with the same security with which he breathes, with which he walks."

Emil Nolde, *Crossing the South Seas.*

Creative Techniques **Watercolor**

Creating
Step by Step

1. To begin, we stretch the watercolor paper on a board, attach it with masking tape, and moisten it with water. Onto the moist paper we paint the outlines of the poppies with a fine ox-hair brush moistened with cadmium red. In advance we mix the watercolor with ox gall on the palette so that the colors will blend even further with the background.

2. Using the same brush, we paint the inside of the colors applied in the previous step with a quinacridone red. The ox gall previously mixed in preserves the moistness for a longer time and helps the two colors to fuse.

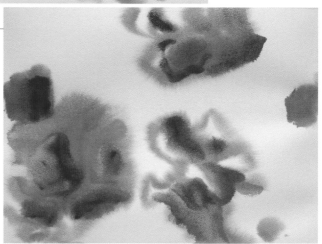

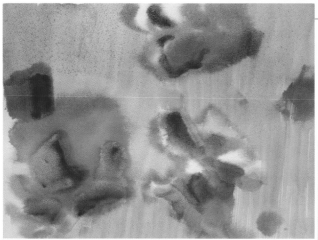

3. Next, we paint the background in a slightly neutralized yellowish green and we thin it with gum arabic to increase its transparency. We have not added any more water, in order for the union of the outlines of the poppies to fuse only slightly with the background.

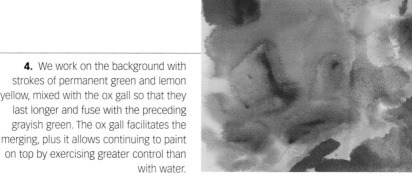

4. We work on the background with strokes of permanent green and lemon yellow, mixed with the ox gall so that they last longer and fuse with the preceding grayish green. The ox gall facilitates the merging, plus it allows continuing to paint on top by exercising greater control than with water.

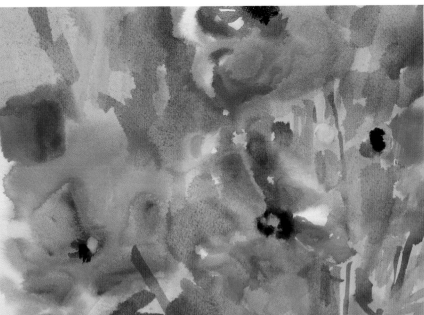

5. In order to continue defining the background, we paint a few strokes in dark greens and grays that create depths and define the background: stems and leaves. We also paint the insides of the poppies in purple and green with a nearly dry brush so it stands out and they do not mix with the red, since their mixing would sully the hues and spoil the painting.

6. To finish up, we let it dry a little and add the petals of the daisies using white watercolor. We mixed it on the palette with ox gall to increase its transparency and create a suggestive superimposition of hues that reinforces the depth of the whole.

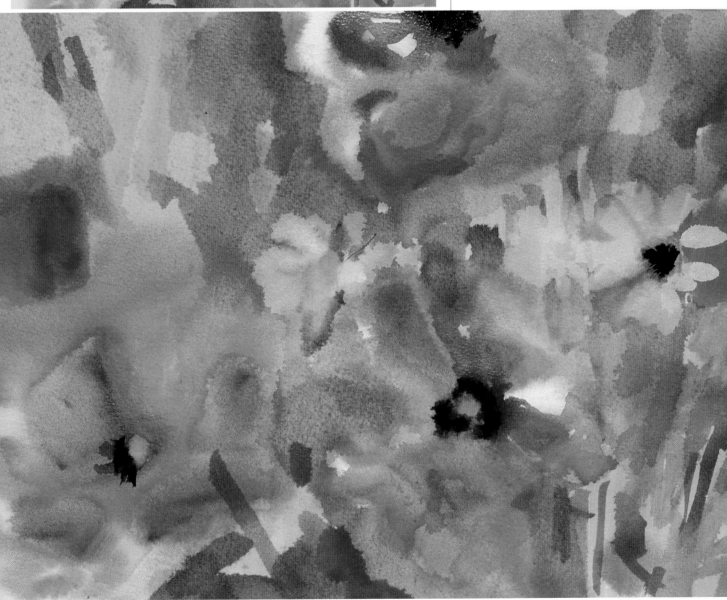

07 Gallery
Other Results

The effect of wet on wet is fascinating and magical. Seeing how a small stroke dilutes and spreads out without our touching it helps us discover that the aqueous mediums do not allow themselves to be controlled at all, and that they establish a dialogue with their creator. These effects vary according to the amount of thinner and the paper being used; these variables are precisely the ones used in this project.

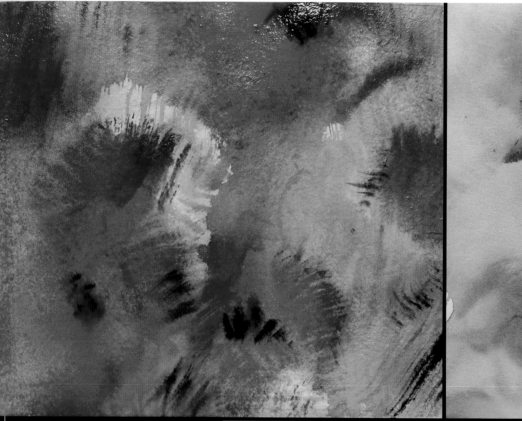

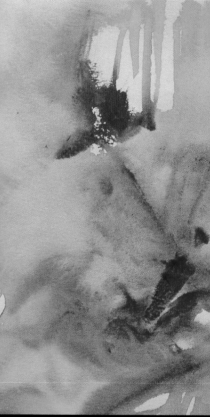

On a handcrafted cotton paper, and using lots of water, the poppies of this work have quickly merged with the background, creating a darker shade. Before it dries, a fan brush was used to paint over it in carmine and black to detail the flowers a little, but allowing the water to fuse some strokes.

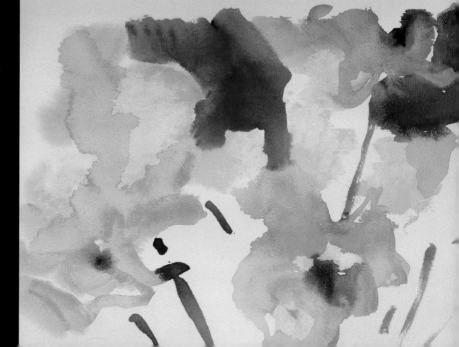

The yellow of the background in this watercolor on fine-grained paper contrasts with the reds and the oranges, creating a warmer and more luminous atmosphere. The carmine shades detail the shape of the petals in a discontinuous manner because they run and merge freely, depending on the amount of water.

The flowers and the background have been painted on a fine-grained watercolor paper moistened with water, and they have been allowed to merge quite a bit. This has changed the shapes and recreated them freely. Afterward, new oranges and yellows were added. The carmines were painted with a synthetic sash brush without using pressure, and with a single pass over the wet hues so that the stroke is preserved.

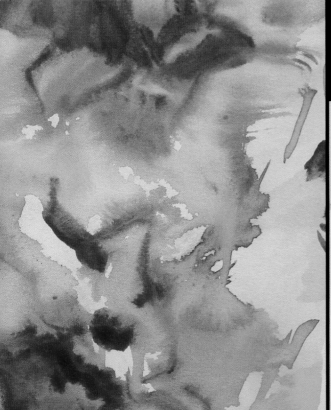

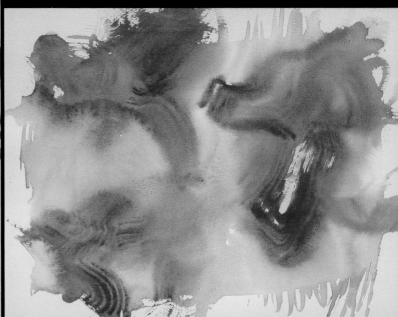

Once again on a fine-grained watercolor paper we paint the most highly contrasted watercolor. The background does not merge with the flowers and it is left unfinished, without painting it, even though the colors do merge inside the flowers and they are allowed to mix

This is the most ethereal and subtle work of the gallery. It was painted on a handmade cotton paper, using an abundance of ox gall and water. The merging has gone to the maximum, allowing the color to lose its consistency and to thin without sullying the colors. In cases like this one, it is advisable to keep a few cotton swabs handy to soak up undesirable excess water.

07 Window
New
Projects

Another Focus The watercolors done wet on wet were painted with clean, transparent hues. The colors were not allowed to muddy one another, but this was not emphasized to excess. To search for another focus and allow the shades to merge, the artist has worked the wet-on-wet effect in a very different way. She has allowed the greenish and reddish hues to mix, creating a muddy, dirty atmosphere by insistently painting over it. Finally, using bleach, she has created light areas and modified the shades, simultaneously restoring shapes that had disappeared in the muddy atmosphere.

Another Model In this instance, Gemma Guasch has chosen to depict the branch of a wild orchid. The subtlety of a single branch in flower contrasts with the group of poppies and creates a very different composition, more deliberate, delicate, and elegant. The first was painted on a fine-grained, handmade cotton watercolor paper with water, allowing the white of the paper to form the leaves. In the second, the work was done on a fine-grained watercolor paper with an abundance of ox gall, so the leaves are pink, because the hues have spread out and formed a new color.

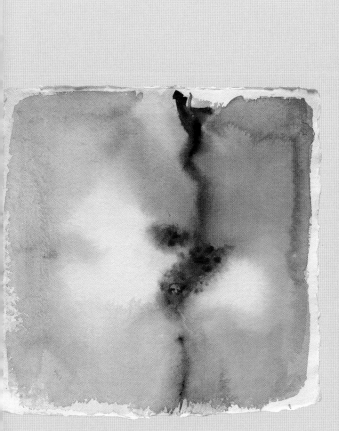

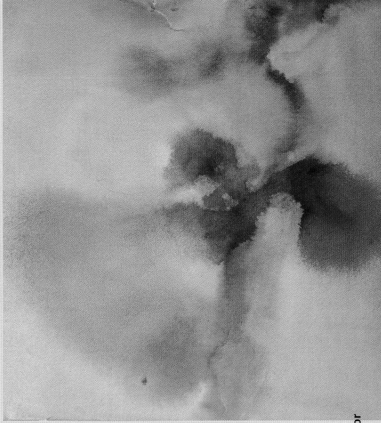

08 Optical Mixing
Creative Project

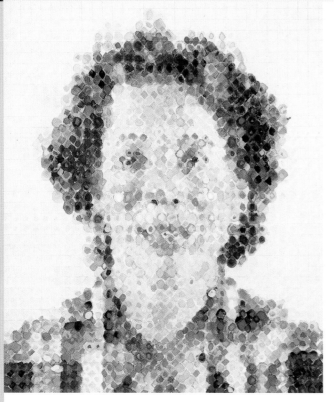

Chuck Close, *Leslie / watercolor II*, 1986.
Private collection.

Known throughout the world for his gigantic close-up portraits, Chuck Close (born 1940) is one of the most important contemporary North American artists. He began painting in New York at the end of the 1970s in a moment of creative turmoil and true interdisciplinary activity. His technique is very simple, but also difficult: He constructs the portrait patch by patch based on a photographic image projected onto the canvas or paper. Instead of mixing the color on the palette, he does it on the support using transparent layers of primary colors, or else through retinal mixing in the style of Seurat, as in *Leslie / watercolor II*, but with a Fauvist chromatic background, since he uses interplays of complementary colors, adjusting them until the combination is satisfying to the eye. He has mistakenly been considered a photo-realist painter, since he uses the camera only to translate the information from the face into two dimensions before beginning, but the final goal is not to imitate that image, but rather to create a new, original state of the image that is fresher and more vital, not devoid of very daring perceptive interplays that conserve the connection with the pictorial above the photographic.

08

Painting a Portrait Through the Fragmented Decomposition of the Image

The following creative project, done by Josep Asunción, is based on the traditional perception in which an image seen up close appears abstract, but from a distance the subject becomes recognizable. He begins with the portrait of an adolescent and breaks it up into small patches on a grid, as if it were a mosaic. Each cell of this mosaic is made up of color applied with a broad, flat ox-hair brush. The support is a fine-grained watercolor paper.

"*What interests me most is that every face I choose has a life that I can communicate and which will move the people who view it.*"

Chuck Close, *interview by Ángeles García for* El País, *February 7, 2007.*

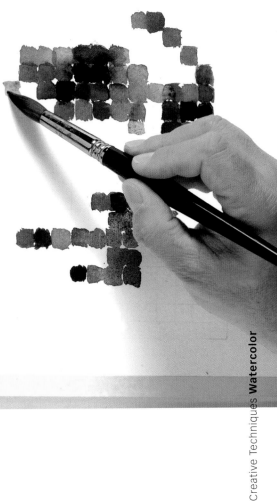

Creating Step by Step

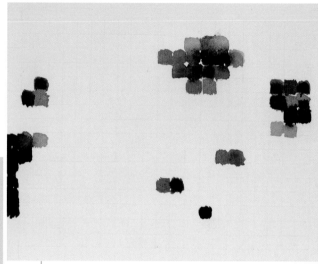

1. The first step in doing this watercolor involves decomposing the image into small fragments. There are two ways to do this. The traditional method consists of tracing a grid over the printed image and then interpreting the average color of each cell. The digital method involves applying onto the image a pixelation filter known as a "mosaic" with a computer retouching program such as Adobe Photoshop; in this case, the average color is figured out by the computer. The artist has chosen the second option.

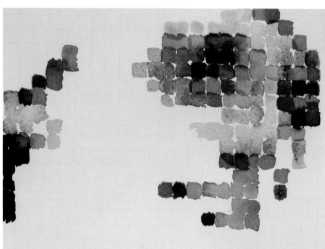

2 and **3.** We prepare the paper using a grid traced with a hard (2H) pencil and corresponding to the selected framing. Once that is done, we carefully erase it to leave only a fine, faint trace. In this faint grid we locate the darkest shades of the face, which are the main features: eyes, nose, mouth, and ear, carefully counting the cells as a precise reference for the distances between them.

4. To give a little body and set the general chromatic tone of the flesh colors, we paint the cells next to the four main points. That way we define the nose, part of the forehead, and the lips. It is a good idea to work out the chromatic scale of the skin on a separate paper, in a gradation from light to dark, deciding which colors will be used in the mix. This is the best way to be on the safe side while painting.

5. We continue to paint the outline of the face; on one side it is defined by the exterior, and on the other, the scarf and the jaw. In locating the background we create chromatic tension with the skin, since this involves cold shades.

6. Now we fill in the medium skin tones. The selected range for the flesh tones contains burnt umber, English red, cobalt purple, and Payne gray. The range in the background contains Hooker green and permanent green, and the scarf uses cerulean blue and ultramarine blue. Note how sometimes the colors of one side invade the other, thereby establishing a very rich chromatic integration between the background and the figure.

7. To finish up, we fill in the empty cells and touch up a few colors. Since we are working with a high number of cells and we cannot wait for the color in each of them to dry before moving on to the next one, it is inevitable for the colors to blend when they contact one another and for the image to blur. We have to wait for them to dry and redefine the cells that are not clear.

Creative Techniques **Watercolor**

The traditional structure for this effect is the square grid; however, it is possible to approach the technique from other types of fragmentation: free brushstrokes, lines, gestures, impacts, and so on. In this gallery, these variations are shown, all done on medium-grained paper, along with a change in framing.

Optical Mixing

Creative Techniques **Watercolor**

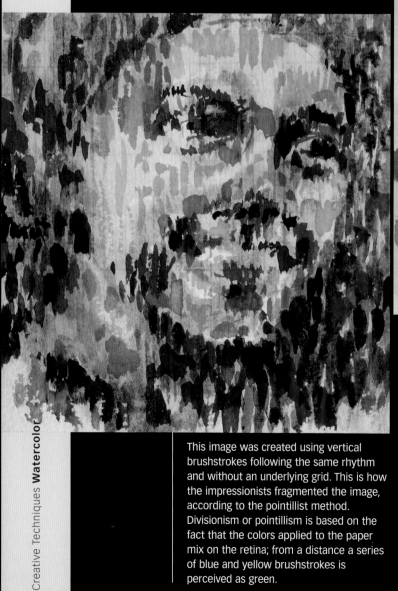

This image was created using vertical brushstrokes following the same rhythm and without an underlying grid. This is how the impressionists fragmented the image, according to the pointillist method. Divisionism or pointillism is based on the fact that the colors applied to the paper mix on the retina; from a distance a series of blue and yellow brushstrokes is perceived as green.

The impacts of color in this watercolor obey fairly free chromatic impulses. Looking at the photographic portrait, the artist has interpreted points of color without worrying too much about the organizing structure, and leaving much of the background uncovered in order to get away from the photographic effect.

In this case, the artist has greatly increased the size of each cell and has centered on a small area of the eyes and the nose. This is perhaps the most abstract image, since there are not many clues to help understand that this is part of a face, although it can be seen from a distance.

The shape of the grid does not matter. We can create a mosaic based on a circle, a triangle, or even a loop. When we opt for more irregular fragments, we must understand that the final result will be more ambiguous and that there will be distortions, such as the images produced through the etched panes of certain windows.

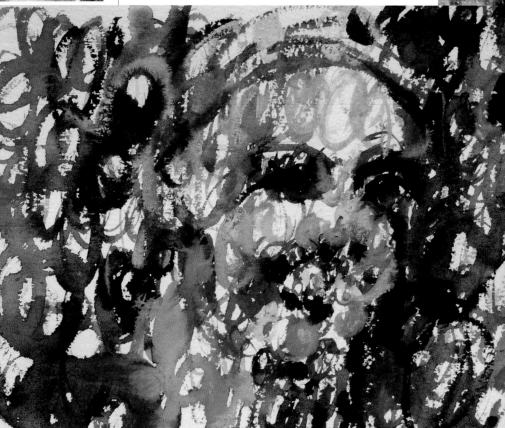

Here the landscape framing and the grid of horizontal strokes create a very suggestive panoramic image. The colors have been allowed to blot on contact in some areas, which gives the watercolor more mystery.

Another Focus The absence of color is a different option that the artist has used in experimenting with other challenges. In watercolor, the palette created with black and white is very suggestive, since the white is the color of the paper and the grays are created by diluting the black. Each black has a dominant tonality depending on the base pigment and has different names: smoke black, ivory black, Davy gray, Payne gray, and so on. In this case, Old Holland brand intense black with a bluish shade was used.

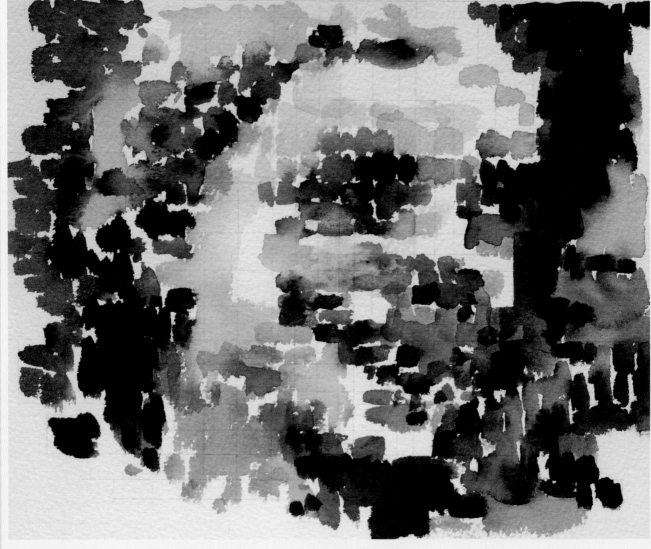

Another Model The work of Chuck Close is based exclusively on close-up portraits, and in this vein the artist has developed a creative project: a very close view of a face. To approach the optical mix of a full-body human portrait he has created another mosaic from a more distant plane. This time he started with a photograph taken under special lighting conditions, since the model posed inside a Documenta 12 contemporary art installation in Kassel, Germany. The installation, entitled *The Radio*, is a work of the artist Iñigo Manglan-Ovalle (born 1961), and among other elements, it involves altering the perception of a space using red filters in the windows, which tinges the reality with this color.

09 Textures
Creative Project

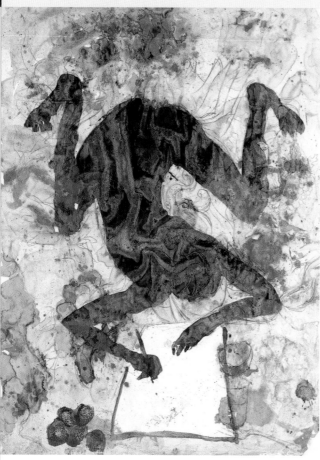

Miquel Barceló, *Peintre dessinant*, 1997. Private collection.

One painter who has experimented extensively with matter is Miquel Barceló (born 1957). A self-taught artist, he began his career at the end of the 1970s. The subject that has always obsessed him is the inexorable passage of time. This is reflected in his work, where he allows matter to move and occupy all the space, and even he marvels at the results. In the 1980s he became the subject of his paintings, generally representing himself nude and painting on the ground, showing us a painter who discovers eroticism and sensuality in this activity. These were also years of intense experimentation and love for the esthetic of poverty. He began using recycled cardboard and discarded materials, so all kinds of things can be found in his works: cigarette butts, footprints, leftover food, dust, and so on. In the watercolor *Peintre dessinant*, painted in 1997, he resumes the autobiographical theme and seeks to make the paint behave like fresh clay, as he says, "in which if you stick in a finger you leave a hole."

Mixing Substances with Watercolor to Create Textured Effects

In this project, Gemma Guasch has mixed different substances in with the watercolor in a desire to experiment with and discover new textural effects. The selected model is a photograph of children running to swim in a river, which she has framed in an attractive, wide-landscape format. The most exciting part of this project is discovering the potential of watercolor when it is mixed with various substances: salt, alcohol, granulation medium, and aquapasto . . . The selected ground is a satin watercolor paper trimmed in proportion to the framing applied to the model. The applicators used are round ox-hair brushes, synthetic flat brushes, and a bristle sash brush.

'*It is somewhat the idea of the painting like a cosmogony, like a type of world with a particular phenomenology that is parallel to the phenomenology of the world. It is these paintings of river, of water, of wet and dry... , but they are also things appropriate to paint, which can be wet or dry.*"

Miquel Barceló

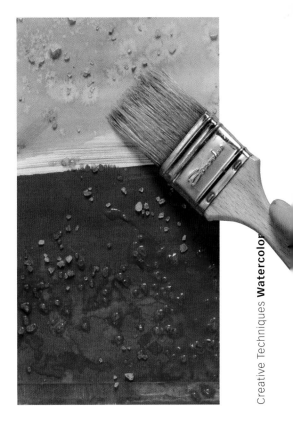

Creating
Step by Step

1. We attach the paper to a board with masking tape. Next, we mix burnt umber with granulation medium and aquapasto in a bowl. The first medium gives it a granular appearance, and the second gives it body and thickens it. We paint the ground using a round, medium ox-hair brush well charged with paint.

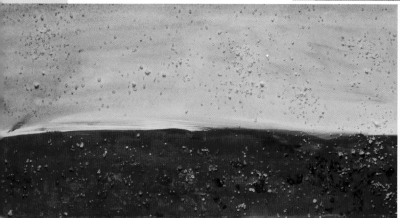

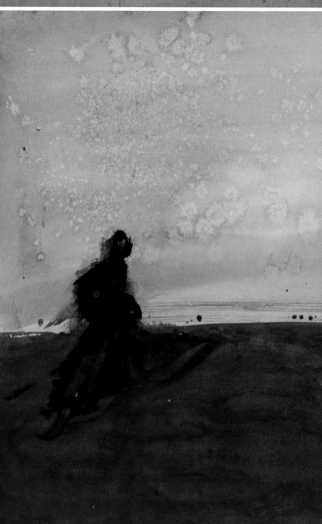

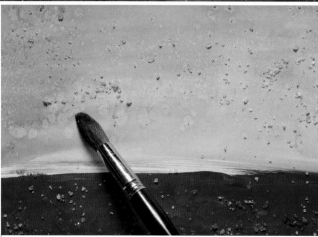

2 and **3.** Using watercolor diluted with water and the synthetic sash brush, we paint the sky in two hues: orange and blue. While the color is still wet on the paper, we deposit grains of sea salt on it. Once the paper is dry, we remove the salt with a dry brush. The salt gradually absorbs the watercolor and the water, creating a curious texture: it opens up light spots where the crystals absorbed the moisture from the support.

4. The salt did not respond uniformly because the layers of paint are very different. To create an effect of texture on the thick layer of burnt umber, we sprinkle it with alcohol, which creates large light areas.

5. Using a fine, round ox-hair brush charged with paint highly diluted with water, we paint the outlines of the three running children in burnt umber. We omit the details and merely suggest their shapes; that way the space is the main subject of the composition.

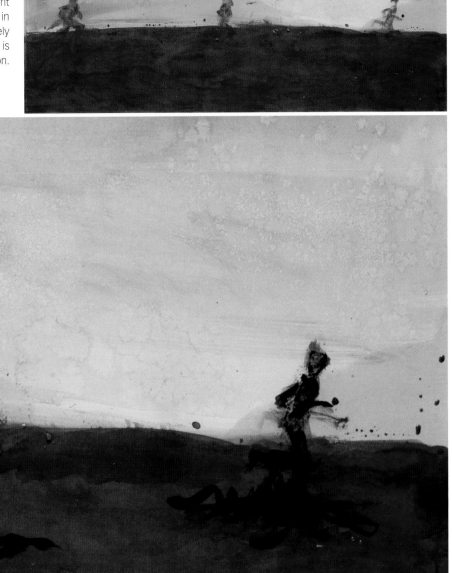

6. Finally, while the silhouettes are still wet, we use a blue watercolor crayon to draw a few free strokes to provide consistency and to slightly muddy the silhouettes. Then we cover them with highly diluted blue watercolor. This partially disperses the crayon and creates a granulated texture.

Creative Techniques **Watercolor**

09 Gallery

Other Results

Gemma Guasch has freely combined mediums and substances in with the watercolor to paint the most experimental gallery in this book. She has used oily substances such as cobalt drier and essence of turpentine, and traditional ones such as alcohol, and mediums that recently have been marketed by some paint brands: granulation, texture, and iridescent mediums.

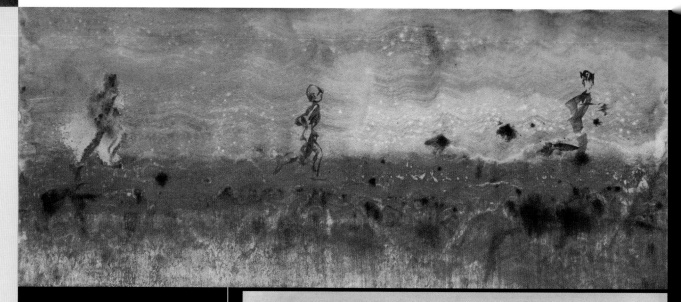

Here the watercolor has been mixed with texture medium and iridescent medium. The former has conferred volume and structure, and the latter has provided a shiny effect similar to glitter. It was used with lots of paint and allowed to dry. Then, in order to create light spots and reduce density, it was sprayed with essence of turpentine. The paper is of medium grain.

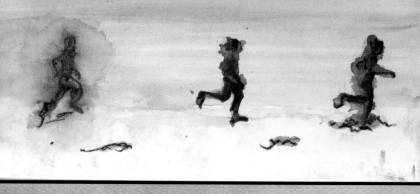

In this watercolor there is a marked contrast between a transparent, white, and clean background and the dense, pasty, and dirty figures of the children. The background was modified by adding bleach, which has "eaten up" the color. Alcohol, essence of turpentine, granulation medium, and watercolor crayons were applied to the figures of the children.

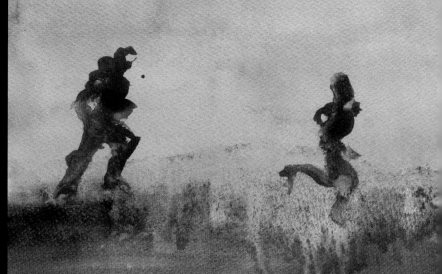

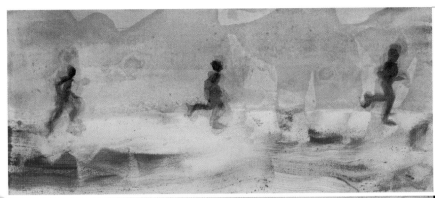

Here the background of the m
paper was first painted: earth
then an abundance of alcohol
onto it straight from the bottle
substance acted quickly, creat
shapes and gradating the colo
were painted on top using wa
watercolor crayons.

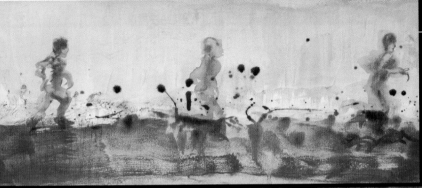

In this instance, on medium-
the watercolor was sprinkle
turpentine, which made it oil
transparent. Then, texture m
aquapasto, and watercolor w
bowl, and this mixture was p
the top. Since the watercolo
did not adhere well and it cr
irregular texture.

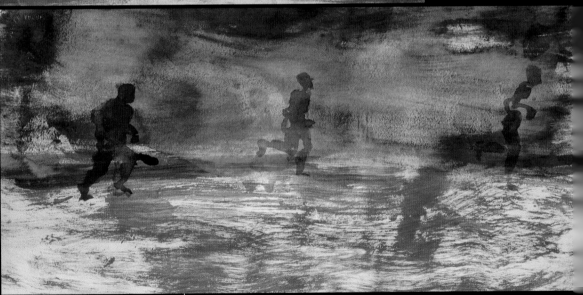

In this image, the watercolor, done on satin watercolor paper, has been mixed
with texture medium and painted onto the paper partially saturated with
turpentine. The watercolor with texture medium has taken on body, but the
turpentine prevented its total adherence, since it is a solvent for oily mediums.
The children became blurry when the watercolor was mixed with gum arabic.

Cobalt drier is the main substance used in this
watercolor painted on coarse-grained paper. It was
applied on top of the watercolor, which was mixed
with iridescent medium. The cobalt drier
attenuated the color by reducing it, but without
losing the iridescent shine.

09 Window

New
Projects

Another Focus In order to vary the focus and continue investigating mixing substances, the color emphasis was changed. Instead of tying the work to a realistic range, it was decided to work on a monochrome background in burnt sienna and contrast it with its complementary color—the blue that is used to define the children. The monochrome background has canceled the horizontal line that located them on the bank near a river. When all visual reference disappears, they run in a limitless and mysterious space. The additives mixed in with the watercolor are ox gall, turpentine, and cobalt drier, which gave the painting a blurry, volatile appearance, highlighting even further the sensation of unreality or a dream.

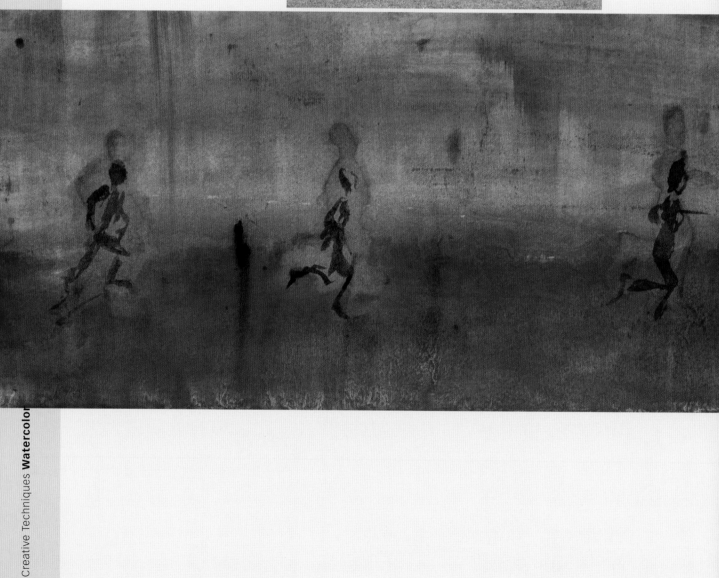

Another Model Any type of subject can be used to experiment with mixing substances into watercolor. In this instance, Gemma Guasch has chosen a simple floral still life. She added salt to the background, which produced an expressive, dynamic texture. The salt absorbed the paint and water, and when it was removed it left numerous white rings. The background contrasts with the rest of the still life. The vase and the flowers were painted wet on wet, a technique that blurred the edges and gave them a poetic, delicate touch. On the other hand, to create the table, the artist merely left the paper white, since with its beautiful texture, it highlights the simplicity that the still life radiates.

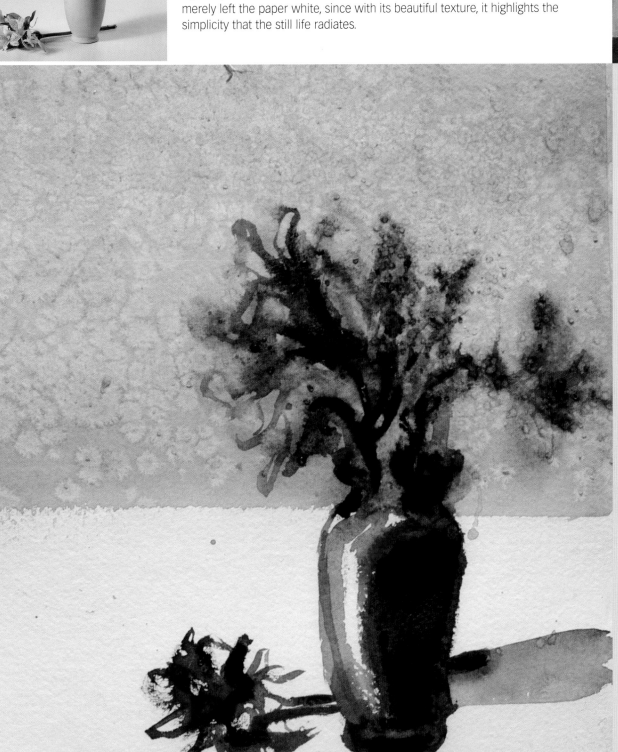

10 Cloisonné
Creative Project

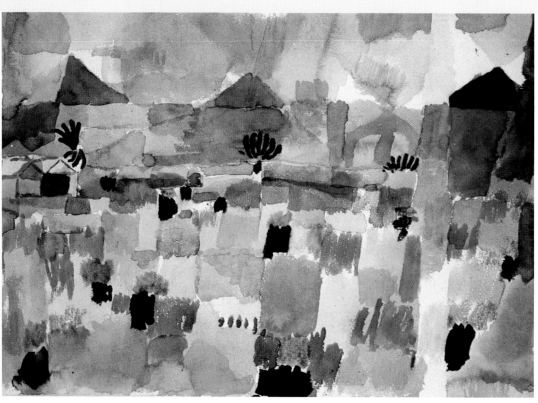

Paul Klee, *Saint-Germain, near Tunis*, 1914. National Museum of Modern Art, Georges Pompidou Center. (Paris, France).

Linked to the German expressionist group *Der Blaue Reiter*, Paul Klee (1879–1940) developed his work between figuration and abstraction. He admired the expressive creations of children and primitive cultures for the purity of their languages. Although landscape was one of his favorite subjects, he never sought to depict nature, but rather to create based on the impulses that nature awakened in him, since landscape was the cosmic meeting place between human and nature. He made no distinction between the imaginary and the real, or the outer and the inner, considering both to be non-contrasting parts of the same reality: the cosmos that unites everything. In *Saint-Germain, near Tunis*, Klee does not seek a global impression of the landscape, but rather a fascination color by color, area by area, and in so doing he applied a traditional technique used for fired enamels and some printed fabrics: *cloisonné*. This technique does not pursue an optical mixing of colors, as the pointillists did, but rather a general effect of order, by classifying every chromatic area inside its corresponding shape.

Constructing a Landscape in Divided Planes and Color Reserves

The technique that Josep Asunción employs in this creative project is *cloisonné*. It involves creating small parcels of "enclosed" color separated from one another. Lines and reserves are used to create this division. The model is a nocturnal landscape. At night, colors fade and contrasts intensify, and this makes it easier to identify each parcel. The painting was done using a round sable brush and a fine-grained watercolor paper.

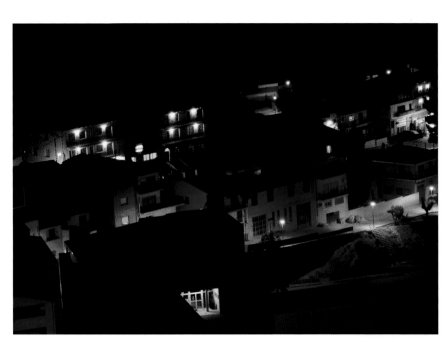

"Color has taken hold of me. I do not need to appropriate it. It has grabbed me forever, I know. This is the meaning of this happy hour; color and I are a single thing. I am a painter."

Paul Klee, *diary*.

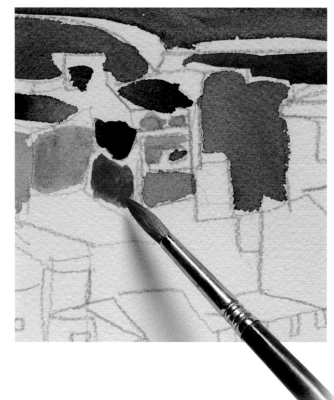

Creating Step by Step

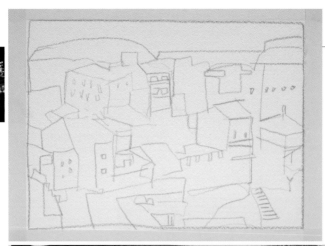

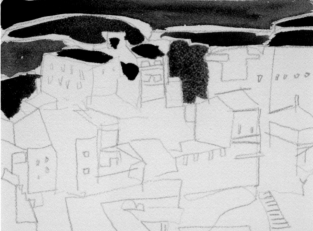

1. The first step in a *cloisonné* work is to divide up the color areas. This involves making decisions in ambiguous areas, since it is appropriate to use dividing lines. We choose to use a blue pencil so that this line will be visible through the end of the watercolor and will have a chromatic note.

2. We establish an order for filling in each parcel. Since this is a nocturnal scene, the rhythm will be descending, and will go from the greatest darkness in the sky to the light hues in the houses. We enrich the blacks chromatically with purple.

3. We continue moving downward, making sure that the colors do not touch one another, and preserving a thread of light in reserve so that the blue line of the drawing is visible. We take the liberty of inventing colors in order to give more shades to the original ones, and to avoid fulfilling the old saying that "At night all cats are gray."

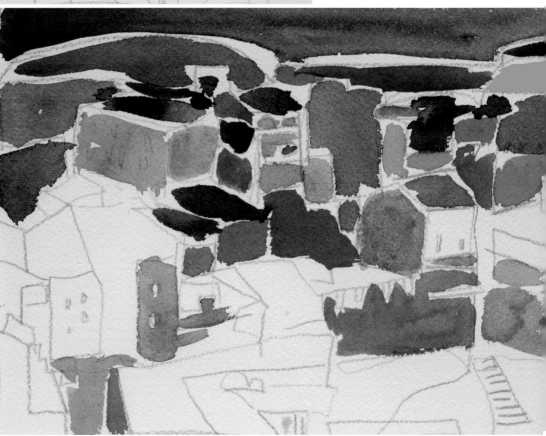

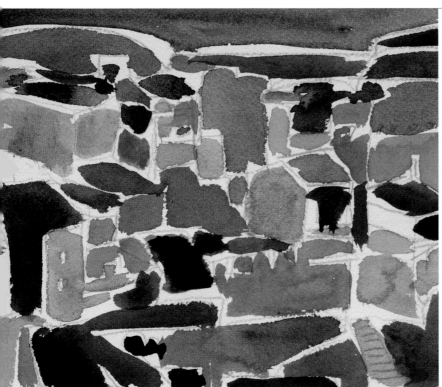

4. To complete the *cloisonné* we finish all the parcels with light and dark hues in different color shades. As we can see, the effect is very flat, since the attractiveness of watercolor is based on the interplay of patches and colors, and not in a lifelike landscape.

5. The final touch involves reinstating the dividing lines of the *cloisonné*. In order to provide more expressive richness, we decide to go over certain lines and put in some new ones with black watercolor and a bamboo pen, which we also use to write a legend in the bottom margin with a reference to the location and the date.

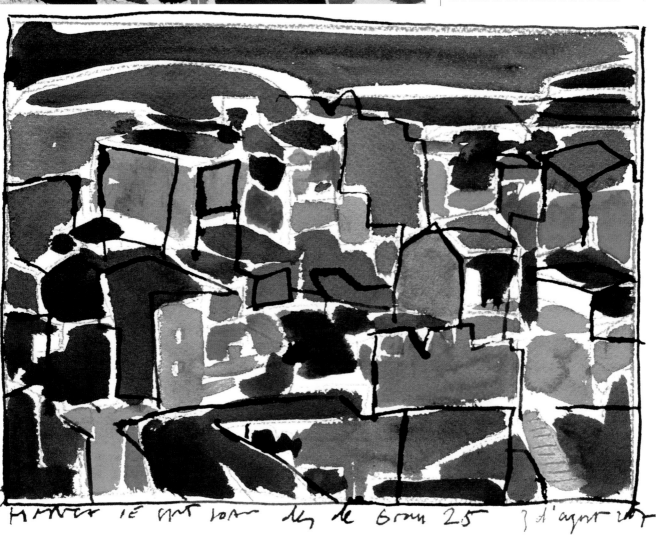

10 Gallery

Other Results

In this gallery the artist displays other *cloisonné* works done using the same subject, but by varying the dividing drawing and the treatment of the colored areas. In all of them the artist has taken the liberty of changing colors or shapes, preserving the same technical interest.

The lines and patches of this small watercolor were created on a piece of gray pressed cardboard. The applicators used were a sable brush and a bamboo pen. Since the background is dark, the colors remain rather subdued, but this is not a hindrance since we seek a certain half-light.

The outlines have been drawn with removable liquid masking on paper handmade in India from cotton textile fiber. Next, each area was painted, and once dry, the masking was removed. Finally it was washed under the faucet, which has muddied the colors and created a suggestive atmosphere.

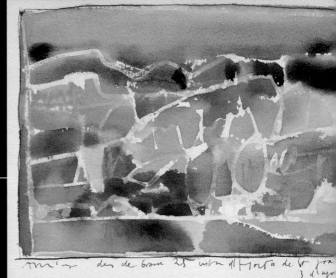

The outlines of this watercolor were done with permanent liquid masking; when it dries it becomes transparent and the paper shows through. This masking is not very thick, plus it does not always waterproof completely; the result is that the colors merge inadvertently when they accidentally come into contact with one another. This is the reason that there are so many gradations. The watercolor paper has a medium grain.

This work, simple in appearance, and done on handmade paper, is a complex one to produce. First a yellowish and pink abstract background was created. When it was dry, the linear outlines were drawn using masking fluid. A general layer of black was painted over the work, and once it was dry, the masking was removed and the watercolor was completed with black lines drawn with a bamboo pen, and yellow ones done with a stick of watercolor pastel.

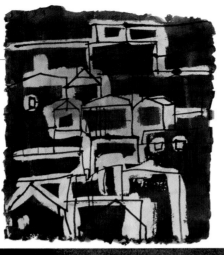

This simple *cloisonné* is very reminiscent of those by Paul Klee. The patches have been kept from touching one another by leaving an open space between them. Still, when they accidentally touch one another, the colors mix slightly, which adds textural effects. The paper used is of fine grain.

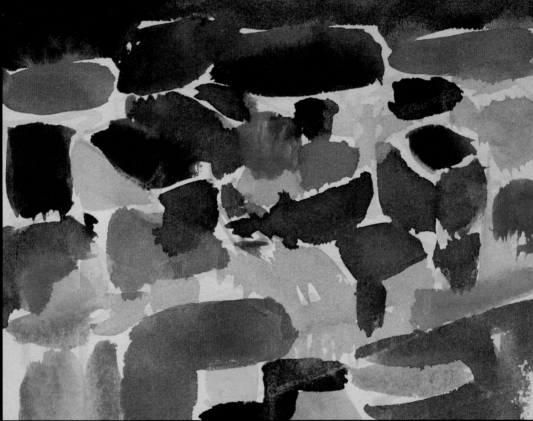

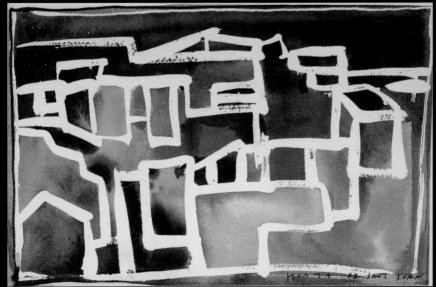

The power of this work is based on the extreme contrast between the parcels and the dividing lines of the *cloisonné*. The colored areas were painted on a fine-grained paper after the drawing using thick lines of masking fluid was dry. When the watercolor is dry we remove the masking to reveal the light from the paper.

10 Window

New Projects

Another Focus The focus of this watercolor is very different from the rest of the project, since it somehow infringes on the concept of *cloisonné*. Instead of containing the color areas to avoid a color transfer, the lines freely overlap with the colors to create a doubly parceled structure: one parcel from the outlines, and the other from the colors. The final effect of this work, which is done on coarse-grained paper, is very free and creative.

Another Model Sometimes nature presents images that invite *cloisonné,* such as the mountains in this model. The rocky formations commonly have ridges, crevasses, hollows, projections, and bushes, which provide the painter with the basic structure without having to think too much. In one of these watercolors the reserve of the paper was left naturally between the colored areas, area by area, and in the other the lines were drawn with a bamboo pen. Both were done by Josep Asunción.

11 Expressionism

Creative Projects

The Austrian artist Oskar Kokoschka (1886–1980) was one of the greatest exponents of European Expressionism. In his autobiography he expressed perfectly the spirit of his work: "People were living in security, and in spite of it, they were filled with fear. I noticed it through their refined manner of living, which derived from the baroque; I painted them in their anxiety and panic." His contact with the German modernists during his long stay in Dresden led him to do a series of watercolors of energetic calligraphy and a brilliant palette, with colors even more intense than usual. In addition, he combined the colors in a way that was detached from reality. In watercolor he found the ideal medium for his expressive needs, since it afforded him an extremely fluid and colorist brushstroke, as shown by *Girl Reclining with Red Dress*, from this period. The girl's pose recalls previous drawings by the artist that likewise had an informal appearance and difficult foreshortening. The luminous brushstrokes of this watercolor serve to reveal the outlines and define the shapes.

Kokoschka,
Reclining Girl with Red Dress, 1921.
Private collection.

11

Self-Expression Through Direct Brushstrokes of Color That Value a Certain Disdain

The expressionist painter Ernst Ludwig Kirchner (1880–1938) defined an expressionist in the following way: "Anyone who expresses himself directly and openly is one of us"; and as early as four hundred years before, the Renaissance writer Balthazar de Castiglione (1478–1529) asserted that in order for a painting to have life the painter must execute it "with a certain disdain." These two concepts—direct expression and a carefree attitude—are the key to this creative project developed by Josep Asunción based on the human figure. This is a portrait done on fine-grained watercolor paper using synthetic brushes.

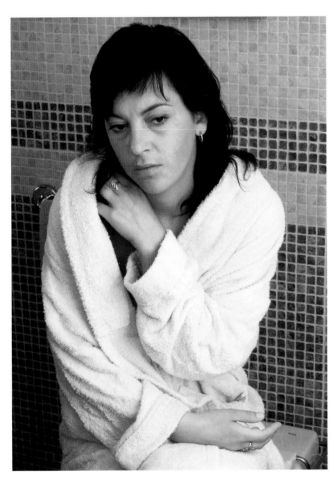

"Expressionism means giving shape to life's experiences so that it is a communication and a message from a Me to a You. As with love, two people are required. Expressionism does not live in an ivory tower, but is directed to someone else you intend to awaken."

Oskar Kokoschka

<div style="writing-mode: vertical">Creative Techniques **Watercolor**</div>

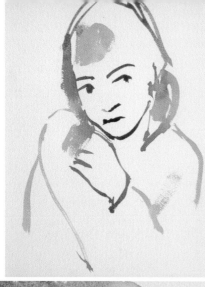

Creating Step by Step

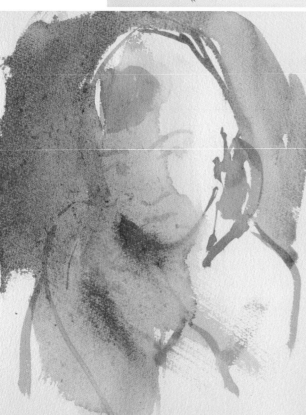

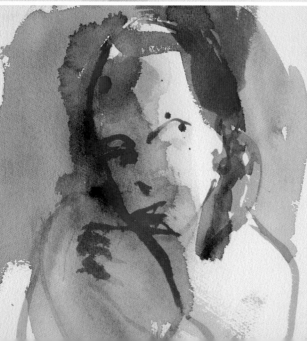

1. The work is laid out by drawing the outlines of the model's main features. This is done directly, without hesitation or corrections; we use a brush charged with a bright color. A synthetic brush is ideal for describing very broad, sharp strokes.

2. We add the first patches to this preliminary sketch. We use two hues: a cadmium yellow for the flesh tones on the face and the hand, and a vermilion for the background and the dark area of the flesh tone. We allow some pooling of the colors on the skin to create spontaneous fades and a certain erosion of the blue, which already was dry but not set, so it was slightly diluted in this orange pool when the brush went over it.

3. To give greater depth to the darks and increase the contrast, we apply Payne gray to the hair and part of the face. We proceed in a carefree way, allowing the color to mix freely with the oranges.

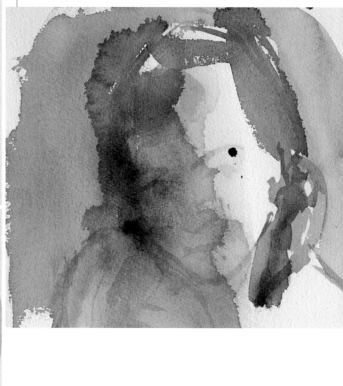

4. We make sure that the watercolor is perfectly dry before intervening again, since we want it to be clearly visible in superposition, without mixing in with the preceding steps. We thus restore the drawing of the face using green, and the complementary color to red, in order to create a forceful contrast. We do not draw the entire face, but prefer to suggest it, leaving a veil of mystery.

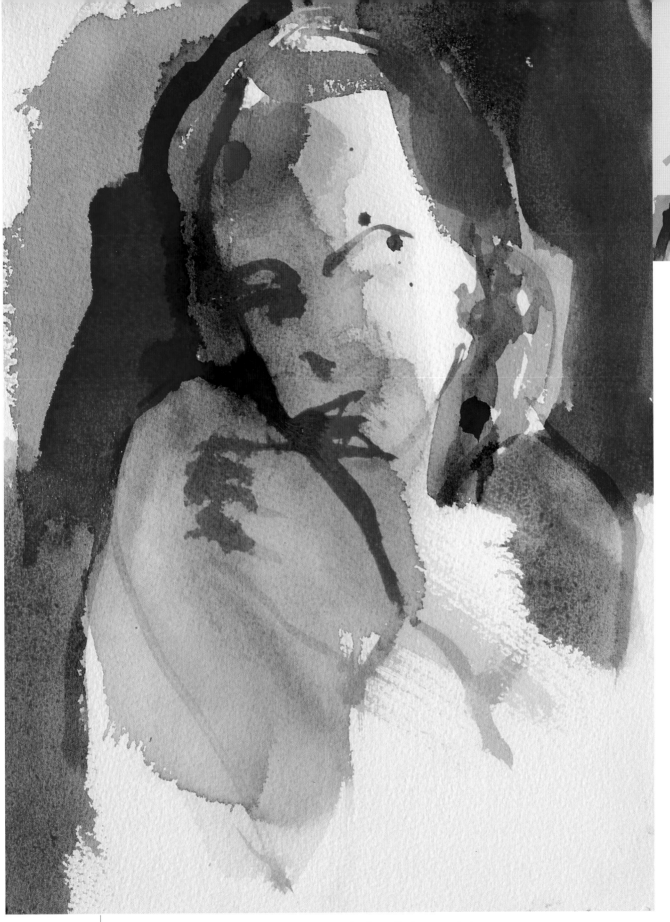

5. To conclude, we add more red to the background to intensify the contrast of complementary colors. With this second pass in red some neutralized hues are produced naturally as a consequence of the fusion of some greens that were not yet dry in the region of the hair.

11 Gallery

Other Results

In producing the following gallery the artist has played with spontaneity and boldness. He has experimented with patches, applying them at different stages of drying with a view to creating natural, capricious fades, glazes, or superimposed clear drawings.

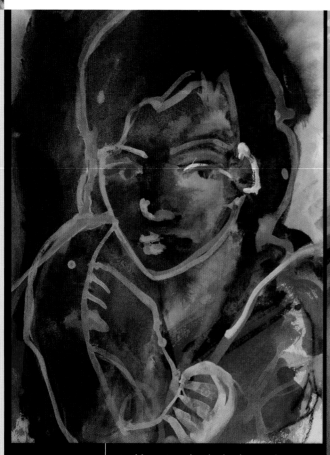

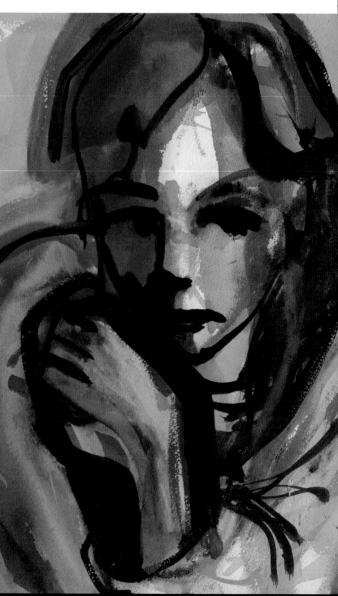

In this watercolor the background was worked extensively; bright patches of color were created, and when they mix with one another they turn gray and neutralize one another. The resulting gray was intensified with smoke black to add drama. Onto this base the face was drawn in luminous orange produced by mixing vermilion and white watercolor. The paper is of medium grain and heavy weight.

This may be the most logically executed work in the gallery, since the patches and lines correspond on a formal level and the result is very figurative. But if we look at the color, we discover that there is a certain arbitrariness, and that, just as with Kokoschka's works, the color functions independently of the subject painted.

This very simple but expressively forceful watercolor was produced by working rapidly and without thinking too much; that is, "feeling" the brushstroke and the color. It was done on a small fine-grained paper using vermilion, turquoise from a tube, and black from a watercolor pastel.

This portrait, in contrast to the others, was done on a small medium-grained watercolor paper. Two watercolors from a tube were used: vermilion and turquoise, and a third color of watercolor pastel pencil, black. When the black from the pencil was applied right onto the fresh pool of watercolor, natural blurs with a beautiful texture were created.

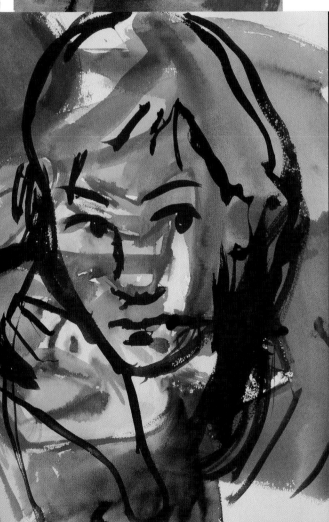

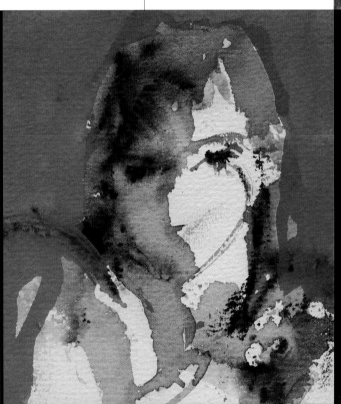

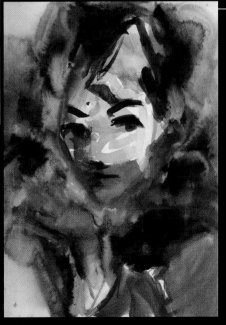

The apparently arbitrary arrangement of color in this work, done on fine-grained paper, is the result of having done a neat, precise drawing of the face in black on a different watercolor that we wanted to recycle. This technique produces an unexpected interplay of color patches inside the face, since each patch responds to a different image.

In this watercolor done on satin watercolor paper, two procedures were mixed. On the one hand, it can be seen that the portrait was done on another recycled watercolor. On the other, the artist has played with pooling dark colors (Payne gray and smoke black) and the stroke of white on that wet patch to create velvety effects through the dispersion of the pigment.

11 Window

New
Projects

Another Focus In this instance a precise, direct line is used to define the subject. This line is done with a watercolor marker, which makes it possible to produce a very fine line but with an aqueous texture. To emphasize this line the color has been used sparingly, opting for somber shades. The textural effect of the black background was produced by mixing the watercolor with lots of gum arabic, working on a satin watercolor paper. The watercolor on a light background, on the other hand, was done on a medium-grained paper.

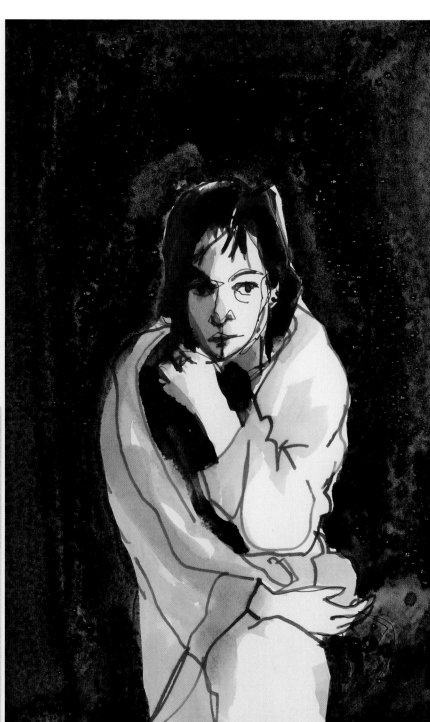

Another Model The focusing of this project on portraiture was inevitable, since the model's pose transmits a major psychological charge. For a change, this time the model was asked to assume a classical pose, typical of German Expressionism: a reclining nude on a sofa. This new pose invites a more formalist treatment, without so much expressiveness, since it entails greater naturalness. The paper used is of medium grain.

12 Fields of Color
Creative Project

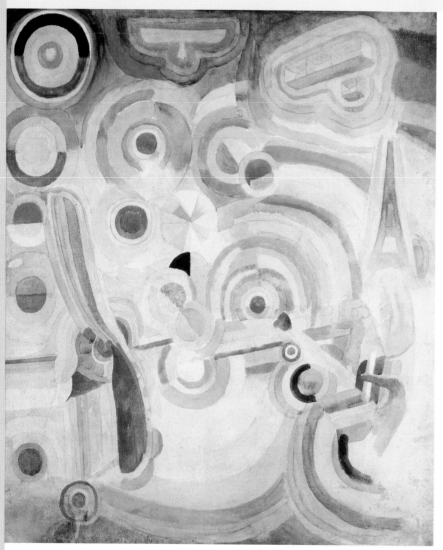

Robert Delaunay, *Homage to Blériot*, 1913–1914. Paris Museum of Modern Art (Paris, France).

In 1913 the poet Guillaume Apollinaire gave the name Orphism to the tendency of cubism that exploited the dynamic potential of color. Historically only Robert Delaunay (1885–1941) has been considered the greatest proponent of this, but in reality two people are responsible for it: the couple, Robert and Sonia Delaunay (1885–1979). Married for more than thirty years (1910–1941), they lived in a creative collaboration based on the same esthetic ideas, and an intense debate, a mutual influence, and the production of projects in common. The reason history has not been fair to Sonia Delaunay is due to the regrettably scant recognition of female artists, and to the fact that she experimented with Orphism, applying it to what was considered "minor art forms," such as textiles and interior decorating, and Robert Delaunay always stuck to painting. Robert Delaunay's obsession was color; he worked from the theory of simultaneous contrasts to give free rein to color and use it in an explosive way. Sonia Delaunay's first abstract painting dates from 1912, which really makes her a pioneer. The Delaunays considered light to be an energetic principle and a vital force, liberated from shapes and volumes. The active subject of their abstractions was pure color distributed in vibrant fields and circles, independent of real references.

Composing Geometrical Abstractions with Flat Patches of Color

Any subject from reality can provide valid inspiration for creating an abstract image, but sometimes that reality appears before us in an abstract form: twisted roots, architectural structures, images under a microscope, and so on. In this project, Josep Asunción does a series of abstract watercolors inspired by the interplay of shadows and transparencies of colored glasses. The model invites geometrical abstraction, and playing with compositional rhythms described on the basis of transparent bands, straight lines, and curves. The work is done using sash brushes and sponge brushes on fine-grained watercolor paper.

This new reality is merely the alphabet of expressive modes that simply drink from the physical elements of the color that the new shape creates. These elements are, among other things, contrasts arranged in one way or another that create architectures, orchestrated arrangements that unfold like sentences in color."

Robert Delaunay, *From Cubism to Abstract Art*, Paris, 1957.

Creating Step by Step

1. The procedure in this watercolor imitates the way light invades a transparent body and passes through it and projects into space. The effect must be smooth, uniform, and vaporous. We begin with the lightest colors; the first "projections" will be yellow, and we will do them with a sponge brush.

2. Next, we move on to the orange bands that partially cover the yellow but still leave some areas white. The rhythm is vertical, and it combines straight lines and curves. We create two distinct patches: The one on the left is hazy, and is the product of several passes of wet on wet, varying the direction; the one on the right is neat and flat, and it was produced by charging the sash brush well and using a single pass.

3. We introduce the cold and dark shades using Payne gray mixed with indigo blue. We locate them in a vertical stripe that has two qualities. On the one hand, a thread of light, which we produce by first passing a pencil brush moistened with water over that bluish gray, and next, a rag to remove the color. On the other hand, a hazy fringe is produced with the lightly charged sash brush and horizontal strokes.

4. We do another pass in the same grayish blue, but this time with greater intensity. This new stroke creates a double rhythm: a pure vertical done with a thick, round ox-hair brush and a smooth, hazy curve done with a broad sponge brush.

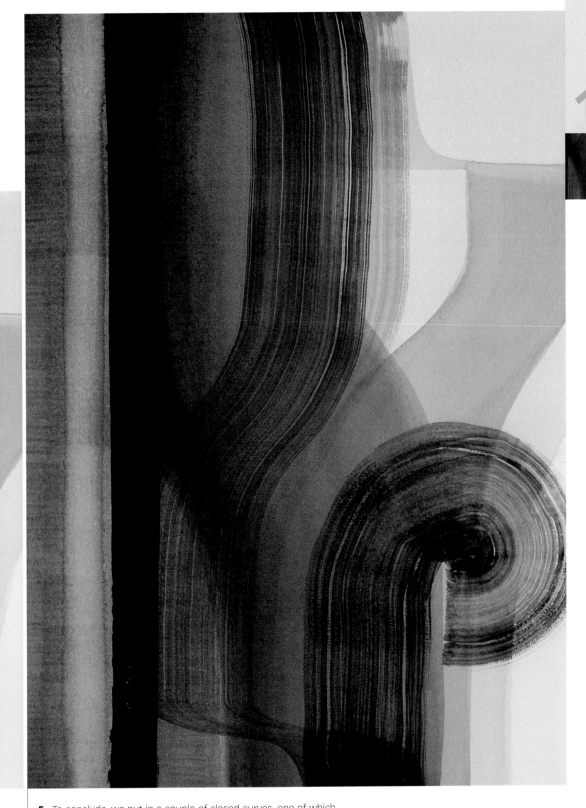

5. To conclude, we put in a couple of closed curves, one of which describes a nearly complete circle. In these final strokes, we increase the amount of blue to gray to encourage greater chromatic vibration with the orange. We use a synthetic sash brush without pressing down in the passes in order to leave threads of light inside the stroke.

12 Gallery

Other Results

Based on what the light suggests as it passes through these colored glasses, Josep Asunción has improvised compositions in different formats and sizes, more or less filling the paper to experiment with density and transparency.

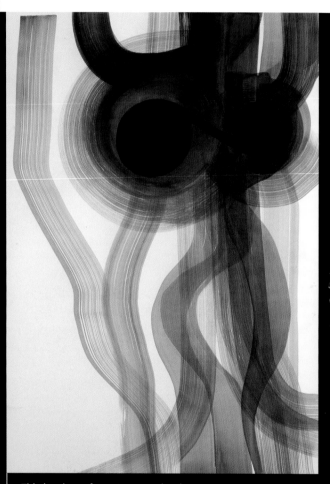

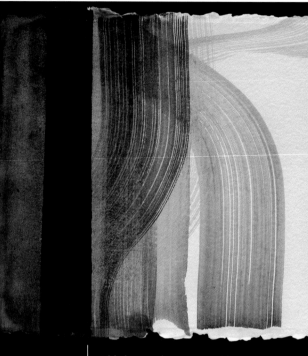

This harmonious composition was done on handmade cotton fiber paper lightly dyed straw yellow. The applicator used is once again a synthetic sash brush; by varying the charge and the pressure applied, we have created different levels of uniformity in the bands. The striations are produced by bearing down gently with a lightly charged brush.

This is a large-format watercolor done on heavyweight satin paper. The composition situates an upper nodule where all the colors are concentrated, and in addition, we find two black circles connected in a dynamic way. All the strokes were done using a synthetic sash brush.

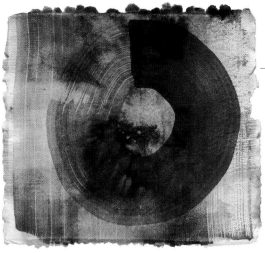

This watercolor, which is more atmospheric than the others, was painted on straw-colored, handcrafted cotton paper previously painted with English red and indigo blue to create a hazy, ambiguous texture. Once this background was dry, we traced a single, cleanly done circle, thereby creating a natural gradation through the loss of color from start to finish.

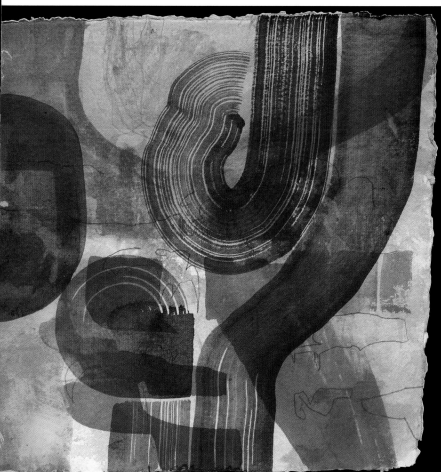

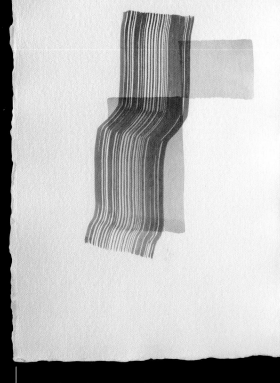

This is a very picturesque composition based on layers of color. It contains distinct trails of color, superimposing each layer of color once the previous layer has dried. In addition, the position of the paper was changed for each layer to break with the logic and create a very spatial final effect.

Here the artist has opted for a very simple composition. Three strokes combined are all it takes to cause an aesthetic emotion. The blue brushstroke, which is intentionally striated, moves on top of the paper and dialogues with the two static, uniform patches behind it, like shadows when they conform to the shapes on which they fall.

12 Window

New
Projects

Another Focus Since the geometrical structure of the glasses is a perfect cylinder, we can use a very different focus if we center on the shape of the circle, even to the point of painting on circular paper. We have thus resorted to using medium-size papers for industrial filters cut into a perfect circular shape. These papers are commonly of very high-quality cotton, and they can take lots of water without warping; but the counterpart to this is that they are excessively absorbent, so we need to load the brush more heavily. In some compositions, the artist has used collage and watercolor markers.

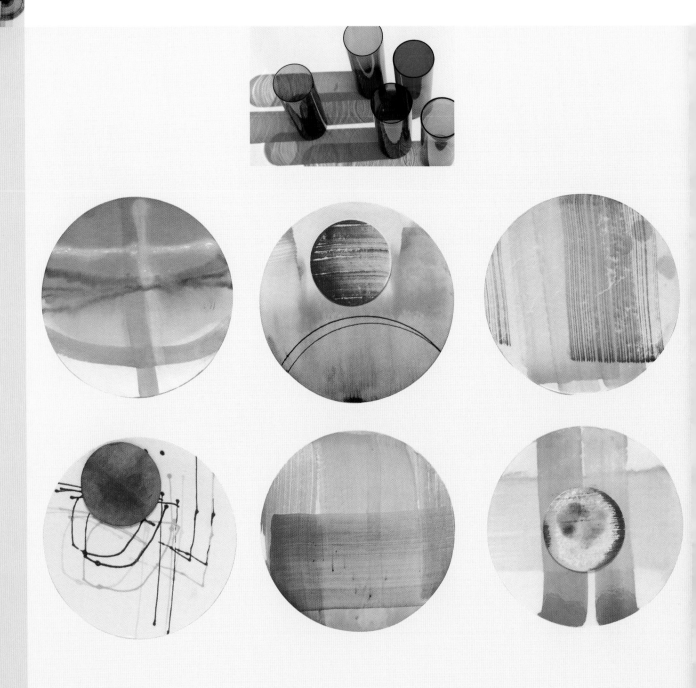

Another Model In the same spirit as the watercolor with the glasses, Josep Asunción wanted to start with another highly structured geometrical image, but with a different rhythm. This time he took inspiration from the glass façades of skyscrapers. Here there are no curves, but rather grids and modules, so everything leads to the creation of groupings of flat, superimposed patches that recall the reflections of light and the adjoining buildings. In one of the watercolors the work was done with a medium, flat sable brush on handmade paper, emphasizing the light and color through intermittent, unidirectional bands. In the other, the artist sought weight and monumentality by covering large areas with strokes from a broad synthetic sash brush, working on fine-grained paper.

13 Gestural Abstraction

Creative Project

Wassily Kandinsky, *Untitled*, 1910. Museum of Modern Art, Georges Pompidou Center (Paris, France).

After the death of Wassily Kandinsky (1866–1940), his wife gave the French government a watercolor he had painted in 1910 that is considered the first abstract painting in history. This assertion has been controversial, for it is known that Kandinsky developed his abstract painting in 1913, and that he found and dated this watercolor afterward. In 1908 *Abstraction and Empathy* by Wilhelm Worringer was published. In his theories and theosophical beliefs, Kandinsky found justification for moving toward abstraction. In 1912 he published *On the Spiritual in Art*, in which he provided guidelines for a new spirituality based on the emotional properties of each color. He compared music and dance to abstract painting to elucidate the latter through incisive analogies. In doing the first watercolor, he discovered that this was an ideal medium for improvising, and from that moment on he knew how to take advantage of accidents and blots like no one else. Captivated by its intrinsic qualities, he used it to investigate, experiment, and even sketch subsequent works in oil.

Exploring the Expressive Possibilities of Gesture in Abstraction

The photograph of a modest spider web woven in the leaves of a plant is the model selected by Gemma Guasch to explore the gestural possibilities that can be produced in this medium. She took inspiration from the contrast between the lines and the masses of the spider web, the leaves, and the branches. Each element suggested an applicator: bamboo pen, nib pen, fine round pencil brush, sponge—a type of line—quick or slow, and an action—spattering, pulverizing, displacing The support is a satin watercolor paper.

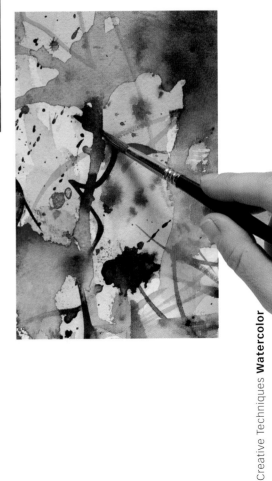

Creating
Step by Step

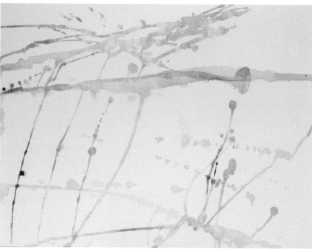

1. On a satin watercolor paper we use a medium round pencil brush to paint some fine lines in highly diluted gray. Once this is dry, we apply a stroke of blue wash over it. In order for the gesture to be undirected and dynamic, we need to do the lines quickly, allowing the brush to leave drips and trails from large droplets.

2. Using a sponge soaked in highly diluted yellow paint, we paint a patch in the center; this creates atmosphere and depth. Once this is dry, we use cadmium yellow to paint a dense, thick stroke to create contrast. Before it dries, we lift it slightly so that the paint moves and forms more slender, less predictable droplet trails.

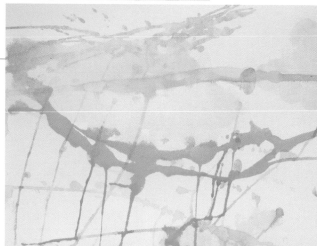

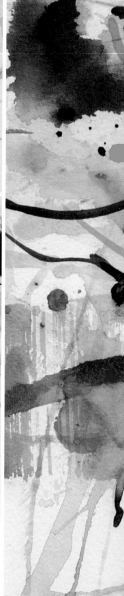

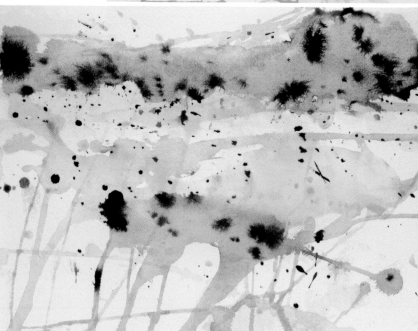

3. We continue painting with a sponge soaked in diluted red and bluish gray watercolor. We speed up the drying slightly by soaking up the excess water with a rag. This allows partial recovery of the yellows and the white of the paper and creates a certain texture. While this is still wet, we spatter it using a toothbrush loaded with purple, allowing the patch to develop its shape according to the moistness of the paper.

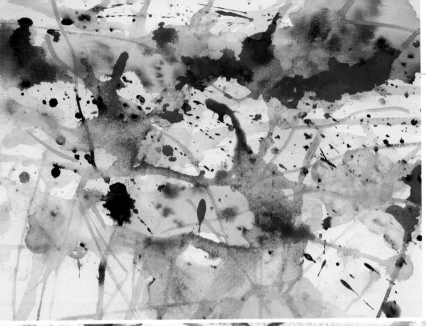

4. We let it dry and decide to reinforce two features by making the color more forceful and mixing the strokes more to promote the idea of a network or a weave. Using a fine round pencil brush charged with paint—orange and red—we paint without hesitation and with a direct, quick pass, letting the paint spread and take on various shapes.

5. To put some order into the chaos created, we conclude by adding some black lines drawn slowly in an intentional direction; this is not continuous, and it blurs on the wettest parts of the paper. This final action adds order to the composition and creates spatial depth.

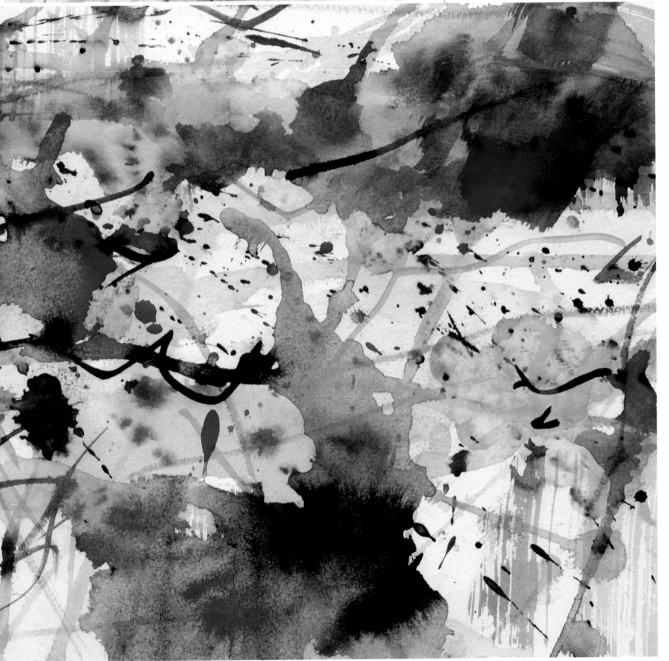

13 Gallery

Other Results

Like Kandinsky, the artist of this gallery wanted to explore the musical potential that is contained in gestures. She has varied the applicators, modified the intensity of the paint, and especially, has changed her physical approach, creating strokes of different rhythms, quick and slow, direct or contemplated, hard or soft, moving between chaos and control.

Clarity and freshness are constant in this watercolor. The paint was applied with a fine round ox-hair brush, a nib pen, and a bamboo pen on a fine-grained paper. Its force lies in the repetition of certain minimal, discreet strokes, along with the beauty of the white paper with no paint.

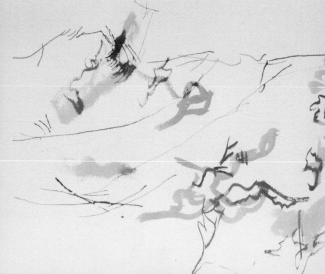

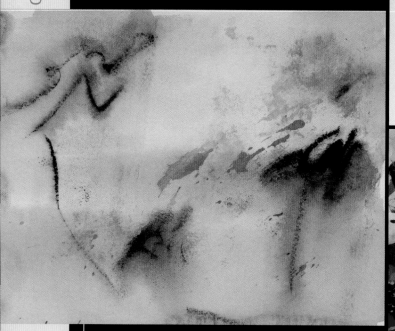

This abstraction, done on fine-grained watercolor paper of heavy weight, communicates a sweet, vaporous melody. First some light black strokes were painted; then it was washed with a sponge so that these strokes have blurred and lost their consistency. Finally, it was spattered with highly diluted red paint, allowing the background to take on density through the moisture.

The most intense and powerful abstraction of the gallery was done on an old page, of light weight, from a notebook. The reds prevail over an opaque, dense background. The strokes were done without using a pencil brush, by letting the paint fall and moving it around in order to produce continual, intertwined trails. In some parts the strokes were allowed to melt and create cloudy atmospheres.

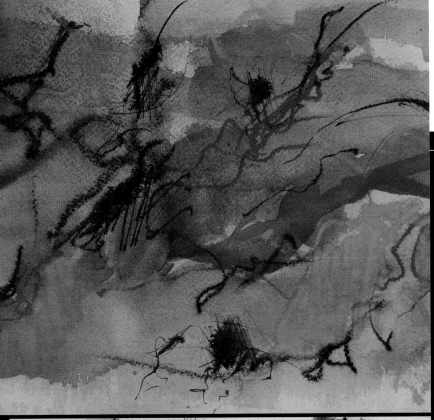

This is the most atmospheric watercolor of all. The lines and the patches were painted quickly and without applying pressure. The applicators used were some round pencil brushes of various thickness, and watercolor crayons. While the paint was still a bit wet, it was washed with a sponge moistened with the dirty water from the brushes. This increased the atmosphere and freely blurred the lines, thereby emphasizing the spontaneity of the composition.

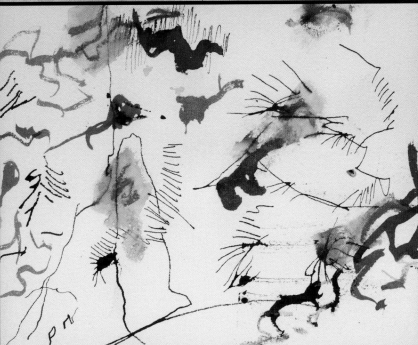

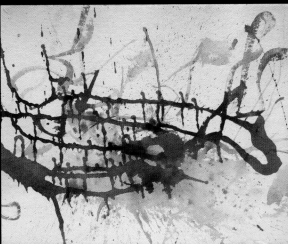

This is the only image that contains a single line and uses no repetition. It was spattered with a sponge, and the impulsiveness and the force of the splashing were left visible. Then quick, direct lines were painted using a pencil brush with light pressure. For the final stroke, the brown paint was prepared in a bowl to produce a sufficient quantity of dark but very fluid color; it was poured onto the paper and spread around by moving it to create large drops.

This work evokes ingenuousness, dynamism, and joviality. It respects to the maximum the white of the paper, and the gestures are direct and graceful. Various applicators were used: bamboo pen, nib pen, and pencil brush; the paper is of fine grain. The paint was diluted so that sometimes the black lines from the nib pen fade; thus, the light areas are soiled, thereby reducing the pretentiousness of the watercolor.

13 Window

New
Projects

Another Focus Without abandoning abstraction and gestures, Gemma Guasch has taken a different focus: creating lines without direct intervention by hand or brush, limiting herself solely to actions that involve no direct contact with the paper. She has spattered, displaced, and pulverized the color, allowing the forcefulness of the action to spontaneously trace the shapes. The paint was highly diluted, thereby providing a focus of fresh, light color. The background of the paper was left clean, so the line was highlighted rather than masking it with atmosphere or backgrounds. The watercolors show the strength and the impact of the action performed without affectation, with the naturalness of showing the instant, without retouching or hesitation.

Another Model Once again the model is taken from nature: a formation of icicles. This model is quite different from the preceding one; here the artist did not intend to create an abstraction from the variety of the shapes, but on the contrary, from the homogeneity. The closeness of the icicles forms a single piece, solid and hard. Thus she painted a watercolor with a dense, atmospheric base. The gesture of strokes that go up and down, dynamic, rapid, and energetic, configures a hollow shape in the middle of a dark, atmospheric haze. To create density, several washes with a sponge were done. Then the lines were painted using watercolor crayons and round brushes. This operation—washing, drying, and adding lines—was repeated in succession to create the desired effect.

14 Combined Mediums
Creative Project

Julius Bissier, *2. Feb. 62 A*, 1962.
Northern Rhine–Westphalia Art Collection
(Düsseldorf, Germany).

Oriental philosophies have had a great influence on some western artists, such as Julius Bissier (1893–1965). He needed to withdraw into himself and search for the spiritual and poetical part of every object. He preferred paper to canvas, a small format, and a combination of mediums: watercolor, inks, collage … . Using these, he created an intimate, delicate, and sensitive body of work with which he invited the observer to meditate. Around the 1930s he abandoned painting on canvas and devoted himself to painting with washes on paper. He stopped painting on an easel and perched horizontally on a table near the work. He was part of a generation influenced by Kandinsky that wanted to contribute "spiritual content" to art, and a purely gestural type of painting held no interest for him, although he was impressed by the paintings of Pollock. The introduction of color into Bissier's washes at first failed, but after laborious research he found a solution made to order: egg tempera technique on canvas. In *2. Feb. 62 A*, the date and the lettering incorporated into the painting reinforce the character of a diary or a book of hours.

Combining Watercolor with Other Mediums to Gain Expressive Richness

In a desire to transcend shapes and express them with simplicity and poetry, along the lines of Julius Bissier, Gemma Guasch wanted to combine various mediums in a still life without a fixed composition. She has chosen free models: glasses, cups and plates, and pitchers ... and has arranged them freely, finding the spiritual part of each shape by means of suggestive washes and fine lines. Various mediums were combined in perfect harmony with the watercolor: inks, varnishes, collage, and gold leaf. The applicators used were very diverse: sponge brushes, bristle brushes, synthetic brushes—round and flat—and bamboo pens. The paper for the support is a watercolor paper of medium grain.

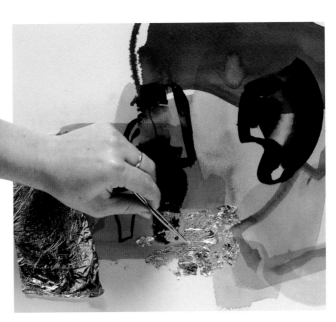

> *"The content is everything."*
>
> **Julius Bissier**

Creating
Step by Step

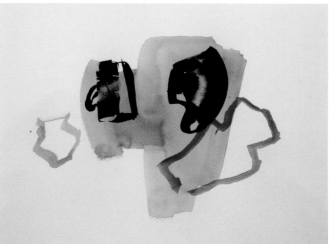

1. Using a synthetic sash brush and paint diluted with water, we paint several base patches in shades of pinks, umbers, and ochres. These first patches are flat and hazy, and they poeticize the outlines of the selected models.

2. We wait for the paint to dry, and using art ink and a sponge brush we draw the shape of the two cups, varying their position. We do this without exerting much pressure on the brush and without retouching; that way we produce a dynamic shape with gradations of shading. We continue with a fine round brush and draw the outlines of the two pitchers, likewise in different positions and sizes.

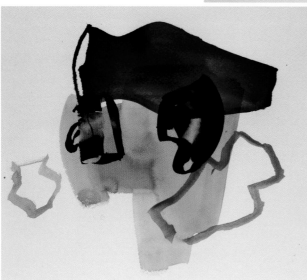

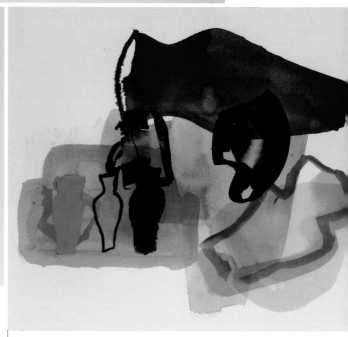

3. We paint a large horizontal pitcher in shades of purple using a synthetic sash brush. We superimpose the shades without losing any transparency.

4. We begin to mix mediums: orange art ink in the lower edges, transparent varnish on top of the red outline of the pitcher, black India ink on the lower two pitchers, and gilded enamel on the third. In this phase, the work breathes an exquisite, rich combination of mediums and shapes.

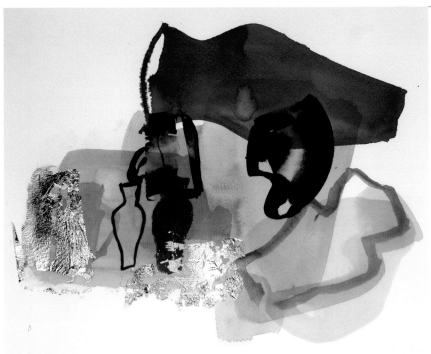

5. We wait for this to dry totally before introducing the collage, which will involve gluing on a fine sheet of gold leaf. For this purpose we put acrylic (latex) glue onto the paper, and with great care, we deposit the sheet and gently press with the aid of a brush. To break with the uniformity, we press with the brush to break the sheet at several places. The color gold symbolizes the divine and adds spirituality to the still life.

6. We balance the composition by painting the flat shape of the plate in yellow. Finally, we draw various pitchers using a bamboo pen and cheerful colors. We make the line lighten the masses and give a happy, jovial touch.

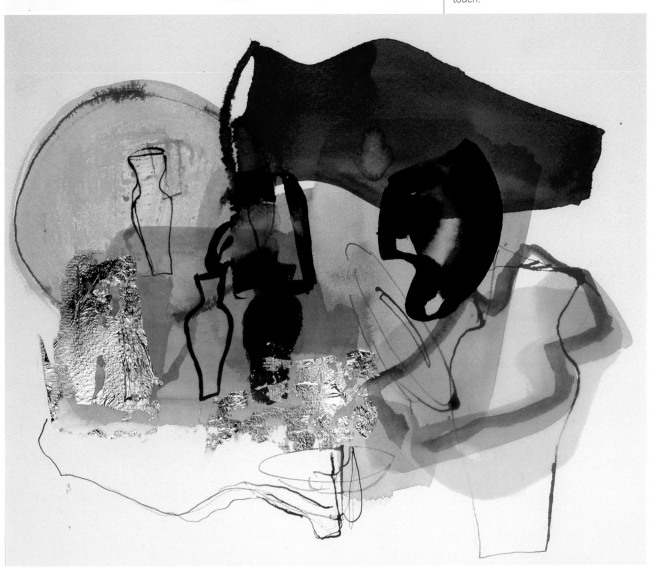

14 Gallery

Other Results

Following the poetic and spiritual line set out by many lyrical artists, Gemma Guasch has sought to seek the *Kayrós* in this work—the right moment or the happy instant; in so doing she has delicately arranged every object, allowing every line and patch to gain strength. The combination of mediums enriches the language, allowing us to experience and enjoy the moment.

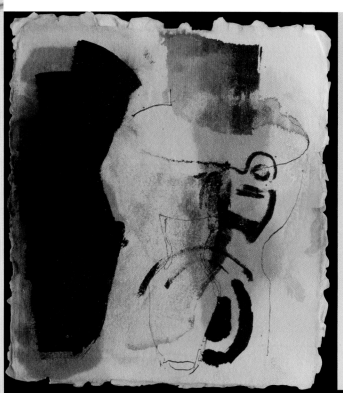

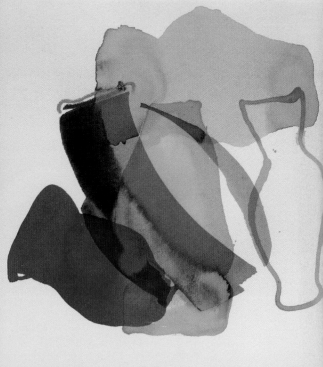

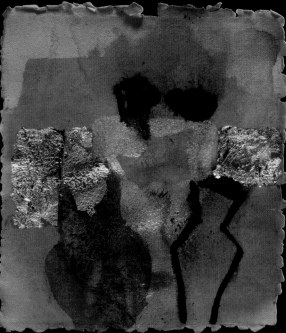

Work done on a handcrafted cotton paper, by mixing fat and lean mediums, essence of turpentine, gouache, art ink, India ink, and watercolor. The applicators used include round and flat sponge brushes, synthetic sash brushes, and bamboo pen. This emphasizes the textures and the gradations created by mixing the inks onto the watercolor sprinkled with essence of turpentine.

Here a light work, with no pretensions or great effects, has been painted onto medium-grained watercolor paper. The mediums combined with the watercolor are art inks, India ink, and watercolor crayons. The applicators are flat sponge brushes and round pencil brushes. In order for the shapes to superimpose over one another without blurring it is necessary to let each intervention dry before painting the next one.

This is the most colorist and atmospheric still life in the gallery. It was painted on handcrafted red cotton paper using India ink, gouache, watercolor, and collage. The applicators were basically synthetic and sponge brushes.

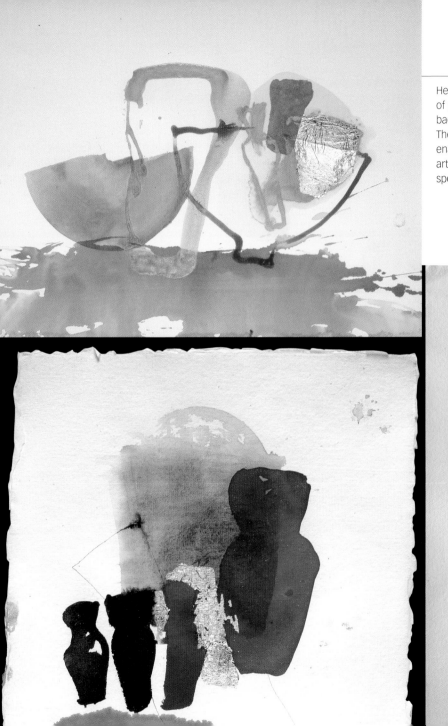

Here is a different result. We see a still life of piled-up shapes painted on a clean background on a satin watercolor paper. The combined mediums are gilded enamel, oil paint, acrylic paint, varnish, and art ink. The applicators used were bristle, sponge, and synthetic brushes.

Combined Mediums

Another Focus In this entire project the goal was another vision as poetical and spiritual as possible. Here it was decided to focus the work directly on abstraction. On cotton handcrafted paper and without being bound to the reality of the shapes, several mediums were combined with the watercolor: art inks, India ink, and silver enamel. The abstraction made it possible to extol the lyricism even more; the shapes have been transformed and blurred without fear and without getting lost in anonymity. The composition was formed by superimposing patches and lines, which freely created suggestive, new spaces.

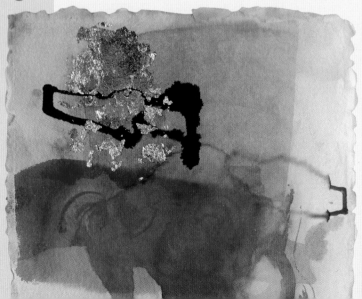

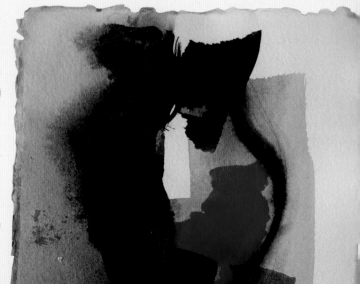

Another Model The still life is a recurring theme for artists who seek to poeticize and transcend the shapes. Gemma Guasch, in continuing to explore this line, has resorted to a simple and austere still life: a plate with lemons. The lemons are arranged so perfectly on the plate that they seem to transcend reality. Once again, the combination of mediums has given rise to rich plasticity: gold leaf, oil, India ink, and watercolor. In this example, the composition is totally central, as is appropriate to the new model.

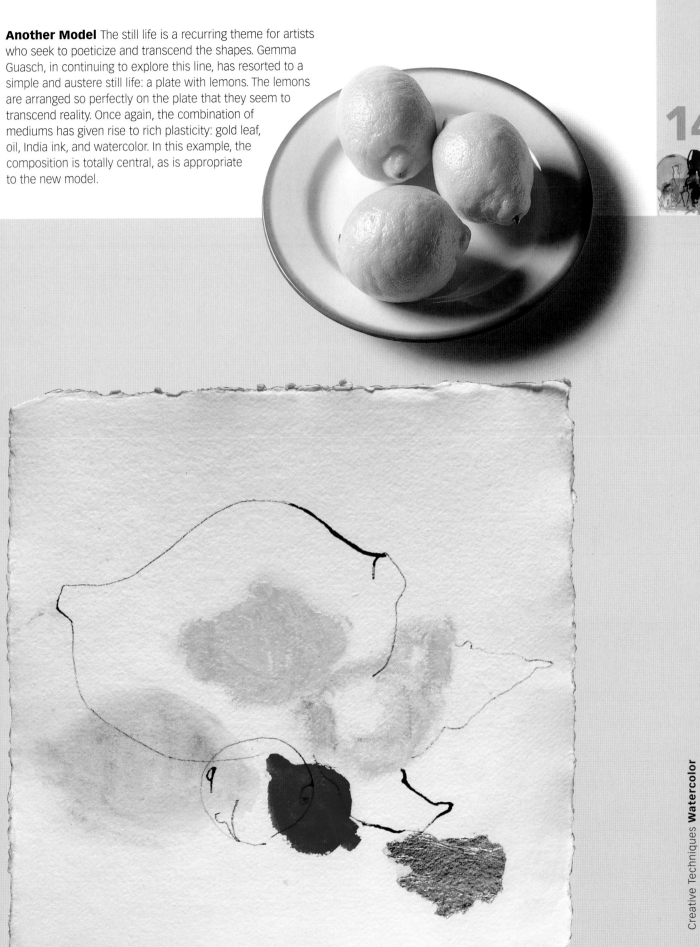

Form

What Is Form and How Is It Perceived?

On the one hand, form is the external appearance of objects; on the other, it is the mental model that aids us in identifying them. We recognize forms thanks to their structure, which is determined by the limits of the object or by its inner structure. In the act of perception, we relate this structure to the prior accumulated experiences in our memory. Perceptively, we do not need the complete information from a shape in order to recognize it (in Figure A we recognize a square by merely seeing

BASIC CONCEPTS

Abstraction

An abstraction is an image in which we are not able to identify known shapes from reality. This does not mean that reality does not contain abstract forms—to verify this we merely need to look at the wear on an old door, or the structure of a building, or look through a microscope.

Abstraction

Chiaroscuro

It is possible to perceive shapes visually only because light falls onto them. But the light creates shadows, and they are as important as the light, as are all the intermediate values. *Chiaroscuro* is the name that we give to this interplay of light and shadow.

Light values in chiaroscuro

Outlines

In reality outlines do not exist; they are a linear interpretation that a painter uses to indicate the limitations of shapes with respect to other shapes or the background.

Outlines

Blurring

This involves acting on a shape in a drawing or a painting in such a way that it loses formal correctness, through such means as erasing, distorting, overlapping traits, or creating ambiguities. The ultimate purpose is to give more importance to expression than to representation.

Blurred face

Structure

The formal structure is the internal framework that every object possesses. Sometimes this structure is real, as with the human body; at other times, it involves a geometrical figure that can contain the shape, such as a sphere, cube, or cylinder.

Formal structure

Mass

This is the space that a shape occupies in a picture. Mass implies a visual weight, and this weight is determined by its size and the density of its colors and light. A large mass of light or diluted color has less weight than a smaller mass of dark or dense color.

Mass

its corners; in addition, we can direct perception, since it is a mental process and not merely a reflexive action (in Figure B we see the arrows pointing either up or down, depending on our will).

Modeling
This is the treatment applied to the shape to create a sense of volume. Patches are added or deleted to control the intensity of the tones and their degree of dissolution.

Modeling

Approach
The first passes in a watercolor are very important because they distribute the elements that compose the image. A shape is approached from the inside to the outside; that is, from the essence to the details. In this sense, one method for approaching a subject is to fit it or place it into "boxes" or basic figures (cylinders, cones, spheres, cubes, ellipses, etc.). A less academic method involves unleashing a series of intuitive interventions, each of which is supported by the preceding one.

An Approach Through Outlines

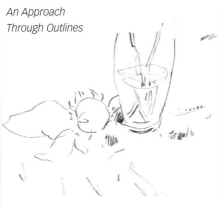

An Approach Through Patches

Silhouette
The silhouette is defined by the limits of the mass in space. The silhouette offers no details, but it communicates the shape if it is positioned properly.

Silhouette

Synthesis
Synthesizing involves reducing the information to the minimum, leaving the essence to communicate the shape. Synthesis can be done with line by reducing the outlines to the absolute minimum, or by means of patches, working with a silhouette or chiaroscuro on the basis of light.

Synthesis of line

Volume
This is the three-dimensional aspect of the shape. The term is used to refer to the degree of visual presence of the image. An image "has volume" when it contains contrasts and the shapes stand out.

Volume

Color

What Is Color and How Is It Perceived?

Color is a phenomenon of perception. Things do not "have" a determined color; rather they are perceived to have a color under specific lighting conditions. A piece of paper looks white in the sunshine, bluish gray in the shadow, and yellowish under lamplight.

Isaac Newton (1643–1727) discovered that white light decomposes into the color spectrum when it passes through a transparent prism. It is the same phenomenon

BASIC CONCEPTS

Chromatic Circle

If we connected the first and the last colors in the chromatic spectrum (magenta and violet) we would form a circle. In this circle there are three pure colors that cannot be made by mixing other colors; these are the primary colors: magenta, lemon yellow, and cyan blue. Mixing the primary colors together produces the secondary colors: orange red, deep green, and bluish purple; and mixing the secondary colors produces the tertiary colors: greenish blue, yellowish orange, and so on.

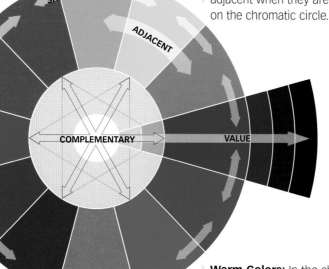

Chromatic circle

Chromatic Chiaroscuro

There are two types of color chiaroscuro: a valuist (or tonalist) type and a colorist type. In the valuist chiaroscuro, the color goes from its lightest hue—mixed with white, to the darkest one—mixed with black or with its complementary color. On the other hand, in the colorist chiaroscuro, black is never used, nor is a color ever mixed with its complement, since the goal is clean colors; in this case, we work with pigments that naturally are luminous or dark.

Adjacent Colors: Two colors are adjacent when they are close together on the chromatic circle.

Warm Colors: In the chromatic circle this is the scale that goes from violet to greenish yellow. Visually they create a sensation of warmth. Black is neutral, but it tends toward warm.

Warm colors

Complementary Colors: Two colors are complementary when they are on opposite sides of the chromatic circle.

Muddied Colors: When the colors in one area of a watercolor are very similar with respect to shade, value, or both, we say that they mud up, or that they are too muddied.

Cold Colors: On the chromatic circle, this is the scale that goes from bluish purple to green. Visually, it produces a sensation of cold. White is neutral, but it tends toward cold.

Cold colors

Neutralized Colors: A color is neutralized when it has been mixed with its complement. Its appearance is grayish and dark because it has lost its liveliness. Such colors are also termed *broken*. Neutralizing a color is the natural way to darken it.

Neutralized colors

Saturated Colors: A color is saturated when it contains none of its complementary color, and no black or white; in other words, it remains absolutely pure, with all its natural energy.

as when solar light passes through raindrops and a rainbow appears—the colors of the rainbow are those of the chromatic spectrum. When light hits an object, it absorbs all the colors of the spectrum except one, which is the one that reflects toward the observer. This is the color of the object under these light conditions.

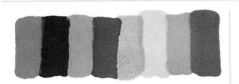

Saturated colors

Contrast

There are three types of contrast. *Tonal contrast* is produced between different colors on the circle; the maximum contrast exists between complementary colors. *Luminous contrast* is between light and dark colors. *Saturation contrast* is a saturated color with a neutralized one. This way, an extreme contrast would result, for example, by combining a pure yellow and a dark, grayish violet, or a deep red and a luminous green.

Divisionism

This technique involves applying the individual colors in a pure state directly to the canvas in small strokes. These ultimately are mixed in the eye of the observer, and they retain all of their natural luminosity. The first divisionists were the pointillist artists at the end of the nineteenth century.

Scale

This is the name given to the set of colors applied to a work. It is also termed *harmonization*, since it refers to the way in which the colors interact. For example, a monochrome scale is based on a single color, and a harmonic triad contains the colors located at each end of an equilateral triangle on the chromatic circle.

Contrast of complementary colors

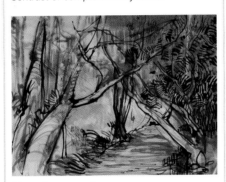

Monochrome scale

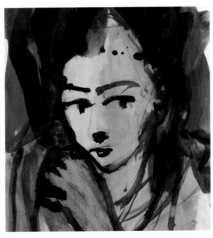

Harmonic triad of primary colors

Tone

This refers to the position of a color on the chromatic circle, not to its light or its purity. The word *hue* is also used in the same sense; thus, a color has a bluish, orange, deep red, and so on tone or hue.

Value

This is the luminous factor of a color. On the chromatic circle, the most luminous color is yellow, and the darkest is violet; but in addition, each color can lighten or darken to approach white or black.

Chromatic Vibration

This is a concept often used to refer to the elements of chromatic contrast that a watercolor contains. This vibration may be subtle or very intense, depending on the contrast applied.

If we dilute coffee with water we lighten its luminous value, yet retain its hue; but if we dilute it with milk, we lighten it and make it blander. The same thing happens with paint if we lighten a color by diluting it or adding white.

Space

What Is Space and How Is It Perceived?

We perceive space visually due to two factors: light and perspective. On the one hand, light makes it possible to perceive shape and depth. On the other, perspective helps us to establish relationships of distance: Things that are closer appear larger, clearer, and with greater luminous contrast. Let's examine a few perception phenomena related to space: gradations (A) produce a visual sensation of depth; in general, darkness suggests greater distance than light. Perspective

BASIC CONCEPTS

Atmosphere

In watercolor, atmosphere transmits a sensation of foggy denseness. When a watercolor has atmosphere, it appears that the patch fills the air with particles and makes it dense and tactile, as with vapor, fog, or dust. An atmospheric watercolor often has recourse to blurring, layers of glaze, and porous, dry dragging to eliminate perceptive clarity.

Framing a landscape

Atmosphere produced with glazes

Composition

This is what we call the distribution of elements in the watercolor. It obeys an expressive intention by the artist and establishes a visual trail: central elements that capture attention, secondary features, and marginal ones. Often compositional schemes that ensure a visual balance are followed.

Framing

This is the selection of the scene. Factors in framing include the format (square, landscape, etc.), proximity (we can get closer to or farther away from the scene), and viewpoint (lateral, frontal, overhead, etc.).

Compositional Scheme

This involves the synthesis of a composition; that is, the general scheme of how the features are distributed. The most commonly used compositional schemes are a centralized composition that is very balanced and static, which centers the subject inside the frame (1); and the right-angle scheme, based on horizontal and vertical lines (2). Diagonal schemes (3) are more dynamic.

1

Central composition

basically works with a reduction in size of objects (B). Overlapping (C) consists of defining the planes of proximity by partially covering the objects represented—the closest one obscures part of the others. Finally, the interplay of focus and soft focus is used to create distance (D), a resource learned from photography.

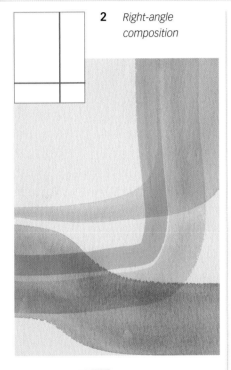

2 *Right-angle composition*

3

Diagonal composition

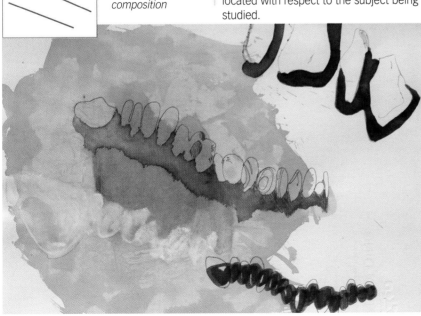

Figure and Background

This is the relationship established between the figure and the background. It involves decisions on whether they are to be separated visually. The background should be considered a fundamental part of the work, not just the physical support of the subject. In order to integrate the background and the figure effectively, it is appropriate to avoid excessive contrasts between the two.

Format

With *format* we understand the shape of the support, although this term also is used to designate the sizes of the works (small format, large format …). The most common formats are the ones established by ISO and DIN regulations, particularly ISO 216 and DIN A4 (approx. 8.2 × 11.5 inches / 210 × 297 mm) and DIN A3 (11.5 × 16.3 inches / 297 × 420 mm) and the standard formats: 20 × 25 inches (50 × 65 cm), 20 × 27.5 inches (50 × 70 cm), and 27.5 × 39.3 inches (70 × 100 cm).

Viewpoint

This is the position in which the artist is located with respect to the subject being studied.

Rhythm

This is the unity in the change and the variety. The rhythm creates a sensation of movement in the work. It is produced by the repetition or alternation of shapes in accordance with a cadence. By varying the intensity or the position of the objects we can produce a visual movement and thus direct the observer's gaze. Filled and empty spaces have equal value in rhythm, just as sound and silence do in music.

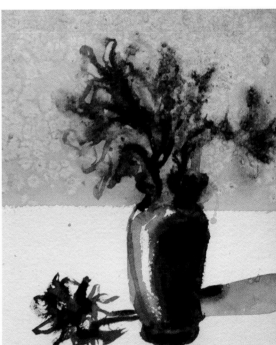

Projected shadow

Projected Shadow

Projected shadows are the silhouettes of the shapes on the plane where they are located, caused by the position and the intensity of the light on these shapes. This option creates the sensation of spatial depth.

Stroke

What Is Stroke and How Is It Perceived?

The stroke is the physical dimension of the picture. The shape, the color, and the composition are elements that refer to the "what" of the pictorial image; the stroke, on the other hand, refers to "how" the image was done physically. It is tied to the materials and the intentions with which the image was constructed, basically referring to two features of the work: the texture and the gesture. In the first case, material factors come into play: the support, the material, and the applicators; and

BASIC CONCEPTS

Gradation

The gradual shift from one color to another or from one shade of gray to another is called gradation. It may be faded and even very blurred, or else without fading, leaving visible every color stage clearly differentiated, or with flat or textured patches.

Faded gradation

Blurring

This refers to a patch that we create by gently rubbing without leaving a trace of the stroke. In general, the blurred surface produces a smooth, misty effect.

Blurred patches

Gestuality

Gestuality is the modulation of the strokes. It is connected to the movements of the hand, and by extension, of the arm, and to the position of the body. Nowadays understanding the expressive possibilities of pictorial gestuality is perfectly standardized, but this is recent, and it is due to the rich contribution from Asian painting, of long tradition in this realm, and to Western contributions from the twentieth century such as North American Abstract Expressionism and the works of Picasso.

Gestural watercolor

Intensity

This is the quantity of watercolor with which we load the applicator. A patch is intense when it contains more pigment than water.

Wash

Washing merely means to remove the color that was applied previously and is at a more or less advanced state of drying. In order to wash a drawing, or part of it, solvent is applied directly or with a rag or sponge, and then it is dried with a rag. By controlling the flow of water and the pressure during the wash and the drying, we can play with atmospheres of greater or lesser density and leave burrs on the strokes.

Juxtaposed Patches

An effect of transparency is created through juxtaposed or overlapping patches. When one patch of transparent color covers another, a visual merging is created; this is one of the most common procedures in working with glazes.

Washed watercolor

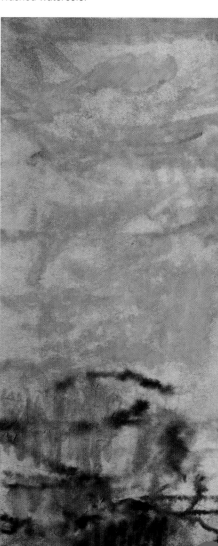

A

B

C

D

E

F

in the second, factors of procedure: speed, intensity, and modulation. Starting with the same model we express ourselves differently with a quick brushstroke diluted with many splashes (A), in a slow stroke with hardly any paint because of a wash (B), using flat blows from a well-charged spatula (C), with a neat, slow, concise brushstroke of fluid color (D), in foggy patches applied with agility, depositing and absorbing the color (E), and with a fine, controlled scratch drawing (F).

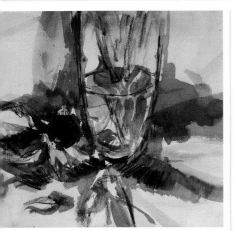

Juxtaposed patches

Visual texture

Modulation

This is the shape that a stroke takes, which is determined by the movements of the hand. We can paint curved, tremulous, angular, flat, confident, impacted, tangled strokes … .

Texture

This is the tactile dimension of a watercolor. It may involve a visual texture created with hatching, a brush, erosion, spatters, transfers, dripping, mediums, salt, alcohol, and so on. The textural dimension of a watercolor adds expressiveness and communicates a greater sensation of reality, since it exceeds the potentiality of the image.

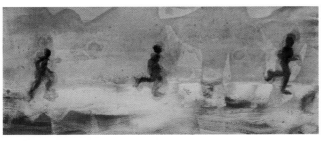

Hatching

This refers to the patch created usually through lines arranged in parallel and frequently crossed. The grid created through the arrangement of these lines is of greater or lesser density and corresponds to a chiaroscuro of a certain value. Hatching can also be done with dots, although this is less common.

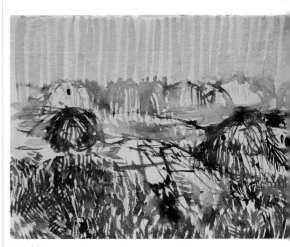

Hatching

Glaze

A glaze is a patch, either precise or extended, done with watercolor highly diluted in water, a solvent, or a medium. With dilution, the color becomes more transparent and makes it possible to see the colors underneath. This is the most typical way to apply a glaze, with juxtaposed patches, although it can also be applied by subsequent washes to create fades and gradations on the support while that layer is still fresh. A glaze creates a translucent effect; it contributes not only atmospheric sensations, but also a greater depth in the color or the grays.

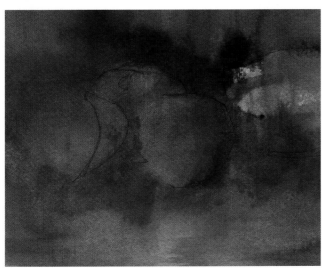

Glaze

CREATIVE PAINTING

FORM
COLOR
SPACE
LINE

FORM
CREATIVE PAINTING SERIES

BARRON'S

COLOR
CREATIVE PAINTING SERIES

BARRON'S

SPACE
CREATIVE PAINTING SERIES

BARRON'S

LINE
CREATIVE PAINTING SERIES

BARRON'S